T0128923

DOES GOD EXIST?
Yes, Here Is the Evidence

HENDRICK PARK

iUniverse, Inc.
Bloomington

DOES GOD EXIST?
YES, HERE IS THE EVIDENCE

iUniverse books may be ordered through booksellers or by contacting:

iUniverse
1663 Liberty Drive
Bloomington, IN 47403
www.iuniverse.com
1-800-Authors (1-800-288-4677)

Because of the dynamic nature of the Internet, any web addresses or links contained in this book may have changed since publication and may no longer be valid. The views expressed in this work are solely those of the author and do not necessarily reflect the views of the publisher, and the publisher hereby disclaims any responsibility for them.

Any people depicted in stock imagery provided by Thinkstock are models, and such images are being used for illustrative purposes only.

Certain stock imagery © Thinkstock.

ISBN: 978-1-4759-7900-8 (sc)
ISBN: 978-1-4759-7899-5 (hc)
ISBN: 978-1-4759-7898-8 (e)

Library of Congress Control Number: 2013903730

Printed in the United States of America

iUniverse rev. date: 3/11/2013

For Nicholas,
Yuni,
and James,
my grand children

TABLE OF CONTENTS

PROLOGUE

There are two dozen known arguments for the Existence of God. This writer has selected 10 arguments and present here, which are most valuable and obvious and easy to understand.

Then, why is the question of the Existence of God important? It is because the God – question concerns every one of us. At the end of our lives, at death we all face either God or nothingness. It obviously concerns us to know ahead of time which is the case. In other words, does God exist or not? Many individual persons regard God and their ultimate destiny as inseparably tied. The God-question is personal to us in the sense that death is personal – that is, it touches and concerns each person deeply. The fact that you and I will die some day is not a matter of personal preference but an "objective" truth. This objective truth touches you and me personally.

Phenomena in nature and in the human experiences which reveal the seeming evidence of design are countless in number. These seeming evidences of design clearly suggest that there is a Mind in and behind nature. Theists identify this Mind with God. This God is a personal Deity of moral nature, Who revealed Himself as such.

Finally, I am glad to acknowledge my wife's contribution through her support during the whole course of my preparation for and the writing of this book.

PART ONE

Argument from the Existence and
the Phenomena of the Universe

INTRODUCTION

The Astonishing Universe Exists and Demands an Explanation

I was born and raised in a home which did not have a contact with any religion. But in my mid-teenage I began to wonder whether God exists or not, and the question remained in my mind for many years to come. It seemed to me that the question of God's Existence is the most important question for humans in life. There are many important questions in life for humans to ask and find the answer for them, but none is as important as the question of God's Existence. And I thought that it is imprudent and unwise for a person to decide one way or the other regarding this question without a careful consideration.

Several years later I went to the worship service in a church near my home once in a while. A few of my high school friends were Christians and they regularly attended the church service. Apparently they had some influence on me. I became interested, but I did not have a belief in God and in the Christian religion. Not yet. I had an inner conflict in my naturally skeptical mind for some years.

I began to read books about the question of God. I began to read scientific books as well. Gradually I realized that the question of God's existence cannot be solved once and for all because of the very nature of the question, even if I wrestle seriously with it intellectually, and that it cannot be solved by intellectual method alone, but by both intellectual method and experience in the real context of life.

As I grew as a human person through various experiences in life, my outlook on life changed as well; and this had an influence on my thinking about the Existence of God. To express more specifically my outlook on life and my thinking about God's Existence evolved in mutual relation and influence. And gradually I came to think that it is difficult to doubt the Existence of God in view of "many clues" which I have found in the course of my academic study and experience. It took some years for me to reach this conclusion.

In the meanwhile, I have read books written by atheists as well and I weighed their arguments. I found out that Atheism has too many difficulties intellectual and otherwise for me to embrace. Of course, Theism also has some difficulties of its own. On comparison, however, I thought that Theism has far fewer difficulties than Atheism. The major difficulty with Atheism is that it cannot adequately explain the origin of the universe and the origin of the human mind. Although there are atheists everywhere, I have not seen or heard about an atheist who adequately explained the origin of the universe and the origin of the human mind. The existence of this astonishing universe keeps demanding an explanation.

It appears that there are four theories that the atheists have put forward so far concerning the question of the origin of the universe. One of the four is that the existence of the universe is a brute fact and we need not bother to ask about the question of its origin. Bertrand Russell, a well-known English atheistic philosopher is one of those who held such a view.

Another theory is that both the universe and the human mind came to exist by accident. But the idea that the wonders like the universe, the beauty of nature and the human mind came into existence by accident seems bizarre and fantastic and I feel that it is difficult to accept it as a respectable theory. The universe is too astonishing and awe-inspiring to be a product of blind accident. And it is too grand and exquisite. If any person really believes that this astonishing universe is an outcome of a blind accident, it is an extraordinary kind of belief. And I think that it is a belief more difficult to embrace than the belief that there is a God who created the universe and the human being.

The third theory holds that the universe has no beginning or end and has always existed and will exist for eternity. This theory is

accepted by some theists who think that this theory is compatible with Theism. However, this theory of the eternal universe is denied by the current cosmology. We are told that most cosmologists and astrophysicists today favor the Big Bang theory which holds that the universe came into existence some 15 billion years ago. Paul Davies, a theoretical physicist and an internationally known author of scientific books says:

> Nearly all cosmologists now accept that we live in a universe that had a definite beginning in a big bang, and is developing toward an uncertain end.[1]

There is the fourth theory which is being advocated by a small number of physicists, based on quantum mechanics in physics. This theory, called the Hartle-Hawking theory, conceives of the universe that came into existence out of nothing, the spontaneous appearance of the universe. If this theory is correct, then there would be no need of the Creator of the universe, and it will boost the cause of Atheism. However, is this theory well-grounded and accepted by most physicists? It does not seem to be the care. Since this is a scientific question, let us listen to the words of David Bohm, a highly respected quantum physicist.

> An interpretation, such as the various interpretations of quantum theory, is in no sense a deduction from experimental facts or from the mathematics of a theory. It is rather a proposal of what the theory might mean in a physical and intuitively comprehensive sense...

> In essence, all the available interpretations of the quantum theory, and indeed of any other physical theory, depend fundamentally on implicit or explicit philosophical assumptions, as well as on assumptions that arise in countless other ways from beyond the field of physics.[2]

It is well-known that quantum mechanics, besides being a

scientific theory, is philosophical in nature. A physicist Max Jammer, wrote a book titled *Philosophy of Quantum Physics,* and the title of the book indicates the philosophical nature of quantum mechanics. So I assume that the Hartle- Hawking Theory is not a well-grounded, established theory, credibility of which is generally recognized, but rather a hypothetical theory.

This theory which theorizes that, given the laws of physics as they are, the universe can create itself, has to answer a tough question, "Where have these laws come from?" I quote Davies again,

> Physics can perhaps explain the content, origin and organization of the physical universe, but not the laws(or superlaw) of physics itself.[3]

He also says elsewhere:

> Given the laws of physics, the universe can, so to speak, take care of itself, including its own creation. But where do these laws come from? Must we, in turn, find an explanation for them?[4]

Traditional Theism which maintains that God created the universe also holds that God created the laws of nature and governs the universe according to the laws.

Here we note that the great physicists who initially developed the quantum physics early in the 20th century thought that there is no contradiction between religion and natural science. They were religious persons in their own way. Max Planck, one of them, said:

> There can never be any real opposition between religion and science; for the one is the complement of the others.[5]

Werner Heisenberg also said;

> In the course of my life I have repeatedly been compelled to ponder on the relationship of these

two regions of thoughts, for I have never been able to doubt the reality of that to which they point.[6]

In the foregoing I mentioned four non-theistic theories concerning the origin of the universe. 1. The existence of the universe is a brute fact and there is no need to conduct an inquiry into this origin. 2. The universe came into existence by accident. 3. The eternal universe without beginning or end. 4. The universe created itself according to the law of physics. It seems to me that there are difficulties with every one of the four; hence I cannot accept them. Atheism which cannot explain reasonably the origin of the universe and of the human mind does not deserve a respect as a worldview.

There are alternative views, besides Theism and Atheism, that one can choose. The one is agnosticism and the other is panentheism. By agnosticism we mean the view that the ultimate reality such as God is unknown and unknowable, or that the existence and nature of God is unknowable due to the lack of sufficient evidence. Agnosticism is not Atheism, but a person who holds an agnostic view will not, in many cases, be distinguishable from the atheist in practical terms of behavior and life style. In theory, there is a neutral position with respect to the question of God's existence. However, there would not be a neutral way of living in the real life in which every person has to make decisions and act one way or others. You cannot remain "undecided and not acting". For example, there would be no neutral way between living a self-centred life and living a self-less life with care and concern for others.

Panentheism is a Greek compound word meaning "everything (exist) in God". So it indicates a concept rather different from Pantheism which holds that everything is divine.

Pantheism is a religious belief or philosophical view which identifies the universe with a god. The word pantheism comes from the Greek words Pan (all) and theos (god), denoting the idea that all things are god. Pantheism is incompatible with Theism which maintains a strict distinction between the Creator-God and the universe as a creature. Pantheism is not Atheism, but we cannot regard pantheism as theistic. In my view pantheism utterly lacks credibility.

xvii

Consequently and in the final analysis only Theism and Atheism remain as final options. Does God exist or not? This is a final and ultimate question. There are other important questions and issues in life. However, we would not be able to obtain a viable answer to these questions and issues until we have the answer to this ultimate question of the Existence of God.

As I mentioned earlier, it was through the intellectual study and the experience of life that I arrived at the present belief that Theism is more reasonable and credible than Atheism. Admittedly man's experiences have subjective elements and are subject to interpretations which can vary. But most of the experiences that I will discuss in the following chapters are the common experiences of human beings. I will narrate my extraordinary religious experience in chapter 9 which has given me the conviction of God's existence.

With regard to the force of the evidences and arguments which are presented in this book as grounds of our belief in God's existence the readers' judgment may be different from this writer's, and the reader A's opinion may be different from the reader B's. In this writer's humble judgment, however, the clues and evidences presented in this book are substantial and those who think rationally without bias will respect them. Before we discuss things which appear to be clues to or evidences of God's existence, I would like to call attention to two points. The first point is that God is the Creator of this seemingly infinite and awesome universe. He would be a transcendent Being and is beyond this world of time and space in which we live, and we, the humans, will be unable to prove His existence. In order to prove God's existence we need to have categories and concepts which are adequate, with which to prove; but we do not have them. If we try to prove God's existence with the categories and concepts which are derived from our experience in this world of time and space, it would be somewhat like trying to pour the water of the sea into our tea cup. It is an impossible thing to do. God is too "big" for humans to prove His existence or anything about Him. Time and space, like everything else in this world, belong to the order of creature.

Not only our attempt to prove the existence of God, but also our debate about God's ways and will, apart from God's self-revelation, is a presumptuous act. God is an impenetrable mystery. However,

God does not wish to remain a hidden or unknowable God. How do I know this? There are two facts which reveal this.

1. God provided innumerable clues to his existence in nature and in the experiences of the human beings.

2. God revealed Himself, His nature and His will through the history of God's redemptive work for mankind which is being testified in the Holy Scripture. God provided the Holy Scripture for mankind.

Since God is an infinite and transcendent Being, He does not exist in the same way that a star, a mountain or an ocean exists. If a scientist wishes to prove God's existence, he should not think that he may try to prove it in the way he proves the existence of an atom which is invisible or a star which has not been discovered yet.

In the foregoing I emphasized the impossibility of the proof of God's existence. Then, can we prove that God does not exist? We cannot prove it, either. God as the Creator of all that exist, is an entirely different kind of Being.

Through our common experience we have learned that the kind of a subject matter determines the method by which it is to be approached, known or verified. Science and mathematics and philosophy are interested in discovering truth. Each has devised its own methods for discovering or ascertaining truth. Science, for example, explains or verifies in terms of the causal relation within the natural order. Because of its very nature, science cannot explain adequately anything that is unique or anything that is not subject to strictly causal relation such as a human person, personal relation, love, moral experience and conscience. Suppose someone, believing that the human being has a conscience, wishes to prove it. How is he to prove it? Even if there is a way to prove it, it will not be by the method the scientist uses when he tries to prove the existence of the atom or the cell. If a scientist wishes to prove his love of his family, how will he prove it? It will not be by means of science or mathematics or logic. If we wish to prove the existence of God, we have to use the method which is proper to it. Then, is there a method which is proper to proving the existence of God? Most philosophers

and theologians say that there is none. There is no ground to believe that we can apply the concepts and categories derived from this finite world of time and space to God the infinite and Transcendent, and prove His existence. Yet there are a small number of philosophers who insist that they can prove God's existence. However, we think that they are mistaken.

The second point that I need to mention is that this astonishing universe with countless wonders and marvels demands an explanation as to "how" it has come to exist. There must be a cause and a process for the universe having come to exist. According to a hypothetical scientific theory called *the Big Bang theory*, all the matter and energy in the universe originated from a state of enormous density and high temperature that exploded at a finite moment in the past. According to this theory the universe is still expanding, and will eventually contract into one mass to explode again to complete the cycle; the complete cycle will take 80 billion years.

Although this theory does not explain all the important features of the universe, it is considered to be a better theory than the rival steady-state theory. This rival cosmological theory says that the universe has always existed in a steady state and that it had no beginning and will have no end. I emphasize that the Big Bang theory is a hypothetical theory. This theory is, in this writer's view, not a satisfactory convincing theory, but a speculative theory.

However, we are facing the question of the transcendence of God which discourages and frustrates the human effort to prove God's existence.

The title of this book is, *Does God Exist? Yes, here is the evidence.* By "evidence" I mean a sufficient reason or ground to believe that God exists. I will also use two more words "proof" and "prove". But what I have in mind is not a proof in the strict sense of the word. In this book when the word "proof" is used, it means the presentation of a sufficient reason to believe that God exists.

If God is a transcendent Being that infinitely transcends the human beings, we, humans will not only be unable to prove His existence, but also unable to know that He exists. Even if God exists, we shall not know His existence unless He provides somehow some clues of it for the humans to notice. God can remain as a hidden God, so to speak. How can the humans find a hidden God? Accordingly

we shall find the clues or evidences of God only if He does not want to remain hiding, but wills to make His existence known to the humans, and leaves some kinds of clues for them to see.

There may be clues or traces or signs in the universe and in man's experiences which suggest the Existence of God. If we find those clues, we would be able to infer that some mysterious Being exists behind or in the universe, and which we identify as God. There may or may not be those clues which suggest the Existence of God. Therefore I propose that we search the universe and the human experiences for such clues.

Five Clues that intimate the Existence of God

There have been countless individuals who searched the universe and the human experiences for the clues and signs of God's existence. And many of them thought that they have found what they had been searching for. We shall have an opportunity later to discuss more of the clues of God's Existence, but for now I select five clues and begin our consideration. The five clues are as follows:

a. The beauty of nature
b. The evidences of design in nature
c. The wonder of mathematics
d. The anthropic principle in cosmology
e. The sublimity of nature

We will discuss these five clues one by one in the following chapters.

CHAPTER 1

The Existence of God –
Argument from the Beauty of Nature

How pleasant it is to see the blue sky and the white clouds above our head! Usually we take it for granted that the sky is blue and the clouds are white. But we should not take it for granted. Why do we have the blue sky and the white clouds rather than, say, the scarlet sky and the black clouds? The sky which is scarlet like the human blood and the clouds which are black like the black coal would be horrifying to see. Please, use your imagination and think about it. The scarlet sky and the black clouds above our heads could happen.

Also, think about what it would be like if there were total darkness in the night and there were no moon and stars in the sky. I am inclined to think that the sky is blue and the clouds are white during the daytime and there are the moon and the beautiful stars in the night, and there is no total darkness during the long night because the God the Creator of nature cared for us, the human beings. Therefore, the beautiful and pleasant scenes of nature can be regarded as an evidence of the existence of God.

Nature is saturated with beauty and beauty is intrinsic in nature. The beauty of the white clouds in the blue sky, the beauty of high lofty mountains with white snow on the top, the beauty of the rising sun in the morning, the glorious sunset at the close of a day, the beautiful rising moon and the stars in the night, and the exquisite delight that comes to one who looks at them!

I have stated above that nature is saturated with beauty and that beauty is intrinsic in nature. We observe that not only nature in a large scale is beautiful such as the starry sky, the blue sky and the white clouds, and the high lofty mountains, nature is beautiful in a small scale as well. Consider, for example, the leaves of trees, the colour and fragrance of flowers, the shape of birds and butterflies, the new sprouts of plants that appear fresh out of the black soil.

Unlike the products of nature, man's productions are – except the fine works of arts – aesthetically unattractive. For examples, machines produced by men for utility, and the factories where machines are manufactured. Compare the hammering noises and unsightly scene inside the factory with the way nature works silently and unnoticeably. Compare the disagreeable stinks of chemical works with nature's fragrant distillation. Nature is comparable with music which is a harmony of many melodies. Nature's beauty is universal.

But, for what purpose and for whom is nature beautiful? If there were no human beings that can appreciate beauty, what is the beauty of nature for? Do the beasts, birds, insects, fish and germs appreciate the beauty of nature? When we consider the fact that nature's beauty and man's aesthetic sense match and that man alone in the world, so it seems, can admire and enjoy nature's beauty, we are inclined to think that the beauty of nature is there for human beings.

Since beauty is one of the three major values – together with truth and goodness –, it implies that nature's beauty is not merely for the sensual pleasure of the human eyes; it has a spiritual significance as well. The fact that the three values of truth, goodness and beauty are in correspondence with the intellect, the will and the emotion of man respectively suggests that the universe exists for a spiritual purpose. This fact, together with another fact that nature is instrumental for the moral and religious education of the human beings, strongly suggests that the universe has a spiritual purpose which, in turn, implies that there is a Mind behind the universe. This Mind is called God by the theists.

Summary

The God who designed the organs of the human body for the practical purpose such as survival and prosperity, and designed the fitness of the natural environment – and of the universe – for

living things, also designed the beautiful natural environment for the human beings. In other words, God designed not just for survival and prosperity, but also for pleasure and happiness of the human beings and for their moral and spiritual (religious) education.

These facts reveal that God is not merely a mighty Creator of heaven and earth, but also a personal, loving and moral Deity. These facts match the Biblical testimony about the compassionate, gracious and saving God. (e.g. Exodus 34:6 and John 3:16) So we, humans who are forgiven sinners, are very grateful and love God with our hearts.

CHAPTER 2

The Existence of God –
Argument from the Evidences of Design

Here we turn to our main concern, the question of God's existence. There are over 20 different kinds of argument, known so far, to prove the existence of God. The argument which has the longest history is the Argument from the Evidences of Design, also known as the Teleological Argument. This argument is very simple and easy for people to understand and is the most popular argument among ordinary people. When people observed the phenomena of nature carefully, especially the organs of the body of human beings, animals and birds, they noticed that the phenomena appeared as if they were "designed" for a certain purpose. And people considered this fact as an evidence of the existence of God. In this case those scholars who paid attention to the apparent design in nature's phenomena – including human beings – named their argument the Argument from the Evidences of Design whereas those who paid more attention to the apparent purpose called it the Teleological Argument. I will give concrete examples of apparent design and of apparent purpose shortly.

In the history of philosophy, Greek philosophers are known to be the first who devised the theistic argument from design and the most famous of them is Socrates (469-399. B.C.) The argument of Socrates is mentioned in the writings of Plato who was his disciple, but I will introduce here the argument as reported by Xenophon

who was a contemporary of Socrates. The following is the theistic argument of Socrates.

On learning that Aristodemus the dwarf, as he was called, was not known to sacrifice or pray or use divination, and actually mocked those who did so, Socrates brought him into conversation with him and said:

"Tell me, Aristodemus, do you admire any human beings for wisdom?"

"I do," he answered.

"Tell us their names."

"In epic poetry Homer comes first, in my opinion; in dithyramb, Melanippides; in tragedy, Sophocles; in sculpture, Polycleitus; in painting, Zeuxis."

"Which, think you, deserve the greater admiration, the creators of phantoms without sense and motion, or the creators of living, intelligent, and active beings?"

"Oh, of living beings, by far, provided only they are created by design and not mere chance."

"Suppose that it is impossible to guess the purpose of one creature's existence, and obvious that another's serves a useful end, which, in your judgment, is the work of chance, and which of design?"

"Presumably the creature that serves some useful end is the work of design."

"Do you not think then that he who created man from the beginning had some useful end in view when he endowed him with his several sense, giving eyes to see visible objects, ears to hear sounds?

Would odours again be of any use to us had we not been endowed with nostrils? What perception should we have of sweet and bitter and all things pleasant to the palate had we no tongue in our mouth to discriminate between them? Besides these, are there not other contrivances that look like the results of forethought? Thus the eyeballs, being weak, are set behind eyelids that open like doors when we want to see, and close when we sleep; on the lids grow lashes through which the very winds filter harmlessly; above the eyes is a coping of brows that lets no drop of sweat from the head hurt them. The ears catch all sounds, but are never choked with them. Again, the incisors of all creatures are adapted for cutting, the morals for receiving food from them and grinding it. And again, the mouth, through which the food they want goes in, is set near the eyes and nostrils; but since what goes out is unpleasant, the ducts through which it passes are turned away and removed as far as possible from the organs of sense. With such signs of forethought in these arrangements, can you doubt whether they are the works of chance or design?"

"No, of course not. When I regard them in this light they do look very like the handiwork of a wise and loving creator"

"What of the natural desire to beget children, the mother's desire to rear her babe, the child's strong will to live and strong fear of death?"

"Undoubtedly these, too, look like the contrivances of one who deliberately willed the existence of living creatures."[1]

Socrates drew the attention of his listener to the most familiar phenomena, namely the human body and its organs and tried to

find the evidence of design in them; and he argued from it to the divine Creator. Clearly this is Socrates' version of "the argument from design" and of "the teleological argument." Apparently the eyes were designed for seeing visible objects, the ears for hearing sounds, the eyes brows for preventing sweat and rain from flowing down into the eyes, the incisors for cutting food, and the molars for grinding it. The structure and function of each of these are adapted purposively to serve a useful end, and all of them are seemingly intended to preserve the life and well - being of the body. "Means – to – end purposiveness" can be perceived here. As Socrates says, it will be difficult to consider the organ of the human body (and of any animal body) with such purposiveness as the work of chance. The human organs appear as if they were "designed" by an intelligent mind with forethought; hence many careful observers regarded them as evidence of the Divine Designer. Phenomena of such apparent design are not confined in the human and animal body, but seem pervasive throughout nature.

The essence of this argument is so plain and simple that the argument would have come into the mind of many individuals in all generations who had an interest in the question of God's existence. A man examined closely his 10 fingers and considered how handy and effective they are in performing various functions which are vital to his life and how intelligently and purposively they are structured, and also how the fingers work in perfect coordination. He also noticed the suppleness of the joints of his fingers, their bending only one way, the four fingers' counter balance with the thumb and the soft flesh of the palm. And the fact that there are 10 fingers, and not 9 or 11 fingers, is extremely significant. And he said:

> "I cannot imagine that these amazing fingers came to exist in my hands by accident without any participation or influence of a mind. I am convinced of the existence of God simply by examining my ten fingers. I do not need any more evidence!

Another man is impressed with the fact that man's two eye-balls are placed inside the deep holes (eye-sockets) dug in the skull and the brain is placed in the middle of the skull. It makes sense that two of

the most important organs of the human body are safely protected in the skull which is really as hard as a rock. That the human skull is a hard solid structure can be seen in the fact that the skull usually remains intact many years after the decomposition of a dead body. It is also sensible that other vital organs like the heart and lungs also are protected inside the ribs of the chest.

Another man is amazed to see that the human body prepares itself for the future need. For instance, when a woman approaches the marriageable age, her breast and pelvis develop and prepare to bear a baby. And when she gives birth to a baby the milk is ready to feed it. This arrangement is called by scholars "the prospective adaptation". This wonderful arrangement suggests that there is an intelligent designer behind it. Only an intelligent mind can make such an arrangement.

In addition to the instances of apparent design in the human body which Socrates mentioned, I gave three more, namely, the 10 fingers, the solid skull which protects the eye-balls and the brain, and the preparation of milk for the new-born baby. In each of the three cases, there was an involvement of intelligence. It appears that there was an intelligent plan and design for a purpose, rather than being the result of blind and random accident. The intervention of a mind seems especially evident in the preparation to meet the anticipated need in the future (e.g. the mother's milk for a new born baby). Since the body of woman who gives birth to a baby is a mindless organism which does not have capability to think, the mind which is involved here must be a mind other than that of the woman. This mind which is outside and beyond the woman would be the divine Mind. The ability to foresee and prepare for the anticipated need in the future calls for a special attention, therefore we will discuss the subject again and give more examples of it.

There are more examples of apparent design in the human body besides the ones which Socrates and I have given. If we add the internal organs of the human body, the number will increase. All the organs, internal and external, are to realize and maintain the life of a body, and also to enable a high qualitative life of an individual person. Shirwin B. Nuland, a professor of the medical college, Yale University, wrote a book entitled "*The Wisdom of the Body*" (published in 1997). In the introduction to the book Nuland says that

he was inspired to write the book "awestruck with the amazement" at the wonder of the human body – the mystery of the body's internal machinery. The miraculous intricacies of organs and tissues, the infinite variety of processes by which the body maintains its life and the multicoloured, multitextured fabric of tangible, pulsating organ that represents to him "nature's most exquisite artistry". Nuland says that he is not the first person who uses the expression "the wisdom of the body" and he gave the names of several scientists who had discussed "the wisdom of the body" before him. We understand what they meant by "the wisdom of the body." If there is a manifestation of wisdom (or intelligence) in the human body, it would not be the wisdom of the body itself because the body is a mindless living thing (organism) which cannot think. It must be the wisdom of a Being that is other than and beyond the human body.

We will explain the point by an analogy. Many people are impressed with marvelous functions of a machine called 'computer' which performs seemingly ever increasing important roles nowadays. If the computer's function shows any cleverness or intelligence, it is not the cleverness or intelligence of the computer itself, but of a human being or human beings who designed and made it. And we do not think that the computer came to exist by accident; we know that it was brought into existence by intelligent human beings. Likewise the fingers, teeth and eyes of the human body would not have come to exist by accident. Is this analogy valid? The opinion is divided on whether the theistic argument based on the analogy between the artifacts and the human body is valid. What is your own opinion?

Examples of apparent design are not restricted in the biological phenomena like the bodies of the humans and the animals. They are found in the physical realm of nature as well. The great physicist of the 17th century, Isaac Newton (1642-1727) believed that the solar system appeared too contrived to have arisen solely from the action of blind forces. He said,

> The most beautiful system of the sun, planets and comets, could only proceed from the counsel and dominion of an intelligent and powerful Being.[2]

For many scientists it was absurd to think that the subtle and

harmonious organization of nature is the result of mere chance. This point of view was expressed by another 17th century physicist Robert Boyle (1627-91):

> The excellent contrivance of that great system of the world, and especially the curious fabric of the bodies of the animals and the uses of their sensors and other parts, have been made the great motives that in all ages and nations induced philosophers to acknowledge a Deity as the author of these admirable structures.[3]

Boyle introduced the famous comparison between the universe and a clockwork mechanism. Boyle's remark as well as Newton's express the belief that the order and harmony of nature could not have come by accident, but have come into existence by God's creation. This line of thinking was wide-spread in Britain in the 18th and the 19th century. Obviously it is based on the assumption that the mechanistic aspect of the universe resembles man-made artifacts such as a clock. Some scientists collected the evidences of design in nature and published them in eight volumes of *Bridgewater Treatises* in 1830. The intellectual attempt to prove the existence of God (and sometimes the human immortality as well) from premises provided by the observation of nature is called "natural theology". Natural theology prospered greatly in the 18th and 19th century Britain.

My purpose for which I am writing this book is to help as many people as possible to be a believer in God and lead a moral and spiritual life. However, I am sad that I can present in this book only a limited number of the evidence of the Existence of God. I hesitate to present a large number of the evidence because if I do it will inevitably make a thick voluminous book. It seems to me that the majority of people of today are reluctant to purchase and read a voluminous book. Socrates gave apparent design in the human body and argued from it to the Existence of God the Creator. Needless to say the evidence of God's Existence is found not just in small things like the organs of the body of human beings and animals. It is found throughout the universe and in man's various experiences as well. The evidences which are found in this astonishing universe are large

in number and in kind. So it is inevitable that we select only a small number of them so that this book may not become voluminous.

Paley's Natural Theology

The most famous scholar in the history of natural theology is an English theologian William Paley (1743-1805). Paley was not an original writer but an "unrivalled expositor of plain argument". He wrote a few books in the field of natural theology and Christian apologetics. His best-known work *Natural Theology (1802)* sought to prove the existence and goodness of God from the appearances of nature. This book became a standard textbook for the generation of students in Britain and America and had a long-lasting influence. And his name is still being remembered by philosophers and theologians today. "Suppose, argued Paley, that you were crossing an area of uncultivated land and found a watch lying on the ground. On examining the watch closely you discovered the intricate mechanism of its interlocking parts and how they were arranged together in a cooperative way to achieve an end. Even if you had never seen a watch, you would still conclude that it had been designed for a purpose by some intelligent mind. This mechanism being observed and understood, the inference is inevitable that the watch must have had a maker".

Paley went on to argue that when we consider the much more refined mechanism in nature such as the orderly arrangement of planets in the solar system and the complex organization of living organism, we would conclude that the evidence of intelligent design is even more forceful than in the case of the watch. Paley listed dozens of specific examples including eyes, neck, forearm, spine, knee, the wings of birds and butterflies, the structure of feathers, fins of fish and senses of animals. Paley reasoned that the marvelous construction of eye or of a bird's wing and feather suggested the existence of a master-craftsman who had made these things superbly adapted for the function which they were designed to perform. And if the universe revealed the mechanical regularity of a watch which kept perfect time, we should infer the existence of a Divine Watchmaker.

This is the essence of Paley's theistic argument from design and it is evidently by way of analogical reasoning. The argument from design as developed in Paley's *Natural Theology* is not, as already

pointed out, Paley's original contribution. Over 2000 years before him Socrates of Greece presented his version of the design argument to the citizens of Athens. And in Britain too, numerous individuals, known and unknown, had attempted the similar argument before Paley did. Paley's contribution lay in having collected evidences from wider fields and expounded more persuasively.

The point of Paley's analogy of the watch is this: just as we infer a watchmaker as the designer of the watch, so ought we to infer an intelligent designer of the universe. Paley catalogued the contrivances of nature which reveal the Divine design. He concludes that an intelligent designer of the universe exists and closes with a discussion of some of the attributes of the cosmic architect.

In his argument, Paley used the words "the purpose" and "the design". So if one pays attention to the word the purpose the argument is called "the teleological argument" whereas if one pays attention to the word design it is called "the design argument". However, the content of the teleological argument and the content of the design argument are the same. Both the argument of Socrates and that of Paley are usually called the design argument for the existence of God.

I would like to summarize the main points of the design argument for the existence of God, presented by Socrates and William Paley.

1. We can distinguish artifacts from natural objects; and we know two things about artifacts. Firstly they exhibit curious adapting of means to ends. Secondly they do so because they were consciously "designed" to do so.

2. If, then, we discover some object the origin of which is unknown to us, but which obviously resembles something known to be an artifact, we would correctly infer that it too is an artifact and is a product of intelligent design.

3. Now it is granted that natural objects such as man's hands, teeth, eyeball, spine, etc., do not obviously resemble artifacts. But on close examination, we find that they possess the essential characteristics of artifacts, that warrant an inference to design, namely, curious adapting of means to ends.

4. Therefore by careful reasoning we would realize that natural objects too are products of conscious design. In other words they are products designed by the divine Creator.

Some atheists, however, asserted that the argument from design for the existence of God was destroyed by Charles Darwin's evolutionary biology. Colin Brown, one of the atheistic critics made this allegation:

> By far the most potent single factor to undermine the popular belief in the existence of God is the evolutionary theory of Charles Darwin.[4]

This kind of allegation is unfounded and false. Bertrand Russell (1872-1970) is one of those who made this allegation. Just as some critic's assertion that natural theology was buried by Hume and Kant, the philosophers of the 18th century, is an overstatement and untrue, so atheists' contention that the design argument was destroyed by Darwin is a false outrageous claim.

Darwinism argues that the seeming design which is found in the bodies of the human beings and other living things was not achieved by the creative activity of God, but is the result of the evolution by the mechanism of "natural selection". This Darwinian theory reveals the shortsightedness which regards the evolution and the creation as antithesis. Actually, evolution is one of the means God uses in creation. The evolutionary process itself was designed by God. Darwinism asserts that evolution is being achieved by the mechanism of natural selection. Then we ask, from where has come such a wonder-working mechanism? The Darwinians cannot answer this question. The theists answer that this wonder-working mechanism itself was designed by God. It is one of the means of creation God uses in creation.

The most deplorable features of Darwinism are the contempt for the human being (disregard for man's uniqueness and dignity) and the lack of due respect for morality. These features of Darwinism are inevitable because of its Atheism. The human beings were called by Darwin "the human species" (as the most evolved animals). According to the traditional Theism, God is a moral Deity, and

morality as an expression of God's character and will is the law of God. And the human being was created by God in the image of God; so every human being should be treated with due respect.

The design argument was reformulated and recovered its honor and is today in a solid and strong shape in the judgment of many trust-worthy scholars.

We need to make a clarification here so that there is no misunderstanding. In the debate between the theists and the Darwinians the point at issue is not whether the biological evolution is a fact or not. That is not the issue. The point at issue is over How the evolution happened – the force and mechanism involved and the process. Perhaps a majority of theists today accept the biological evolution and believe that Theism and evolution are not mutually contradictory notions. They think that if some theists still believe that the doctrine of creation and the doctrine of evolution are incompatible with each other, it is due to a misunderstanding. I emphasize that evolution is one of the means God uses in creation. We will come to see what the real content of the Darwinian challenge to the design argument is. The term 'Darwinism' is frequently being used by the Darwinians themselves to designate their point of view.

In our judgment, the Darwinians misunderstand seriously when they claim that the theistic argument from design was destroyed by the Darwinian theory of evolution. Their claim is false and over-blown. Even if we allow that Darwin's biological theory can adequately explain all the apparent designs observable in the organic nature, it explains nothing regarding the evidences of design in the inorganic nature. It is because Darwin's biology is not applicable in the material side of nature. And the material side of nature is vastly larger than the organic side of nature. This fact should not be forgotten.

Darwin's version of the evolutionary theory is atheistic, but Darwin himself was not an atheist until later years of his life. When Darwin was a university student, he entertained for a while the thought of becoming a clergy man and studied theology. However, after he began to study biology he gradually lost his faith in God. Judging from his own brief auto-biography, it appears that Darwin later settled in what he called 'agnosticism', but not Atheism.

Bertrand Russell, as I mentioned above, declared that the

theistic argument from design was destroyed by Darwin. But it is interesting to see that the argument from design keeps coming back with more and more refined argument, and the prospect is that the design argument will prosper even more in the future. An especially interesting development is that not a few scientists show a strong interest in the design argument and present their own argument with great eagerness and conviction.

Paul Davies, a prominent theoretical physicist, describes the situation this way:

>It is all the more curious that the design argument has been resurrected in recent years by a number of scientists. In its new form the argument is directed not to the material objects of the universe as such but to the underlying laws.[5]

Needless to say, there are still scientists who formulate their design argument based on the material objects of the universe.

Here is a fact which we would better keep in mind. It is that the so-called 'design argument' is not the only theistic argument that exists, but is merely one of many. Therefore, even if the design argument were completely discredited, Theism is not in danger because there are still the second, the third, the fourth...defense line.

But the fact is that even after Darwin's criticism the first defense line (if we may call the design argument thus) is still there in a defensible position. We hope to show it in this book. Regarding those who assert that the design argument was buried by Hume and Kant philosophically, we wonder if they have read Hume's and Kant's books carefully because nowhere in their books the two most prominent philosophers of the 18th century made a claim to that effect. To the contrary, Hume and Kant made expressions respectively that they value the design argument. For example, in the closing sentence at the end of his main book which is in the form of dialogue of three persons (Cleanthes, Philo and Demea), Hume lets the careful listener of the dialogue make the concluding statement: "the principles of Cleanthes (who presented the argument from design) approach nearer to the truth" than the two others.

Kant, in his master work *Critique of Pure Reason (1780)*,

explained the impossibility of the proof of the existence of God by the speculative reason of man. Yet Kant valued what he called "the physico-theological proof" (which is equivalent to the argument from design and the teleological argument in the contemporary terms). I quote his note-worthy statement to show the falsehood of some atheists' assertion.

> "This proof always deserves to be mentioned with respect. It is the oldest, the clearest, and the most accordant with the common reason of mankind. It enlivens the study of nature, just as it itself derives its existence and gains ever new vigour from the source. It suggests ends and purposes, where our observation would not have detected them by itself, and extends our knowledge of nature by means of the guiding-concept of a special unity, the principle of which is outside nature. This knowledge again reacts on its cause, namely, upon the idea which has led it, and so strengthens the belief in a supreme Author (of nature) that the belief acquires the force of an irresistible conviction. It would therefore not only be uncomforting but utterly vain to attempt to diminish in any way the authority of this argument..." (p. 520 of its English translation)

Hume also puts a similar view into the mouth of Philo in the *Dialogues*, who is regarded by philosophers as expressing Hume's own view.

> "In many view of the universe, and of its parts, particularly the latter, the beauty and fitness of final causes strike us with such irresistible force, that all objections appear (what I believe they really are) mere cavils and sophisms; nor can we then imagine how it was possible for us to repose any weight on them". (p.202)

The reader will remember that the critics of the theistic argument

(natural theology) asserted that the theistic arguments were destroyed philosophically by Hume and Kant, and scientifically by Darwin. To some people, Theism may have appeared to be a lost cause and its future to be bleak. However, it turned out that the theistic arguments have not merely survived these onslaughts, but remain powerful and convincing.

Theists' experience of these onslaught and the atheists' actual failure to invalidate the theistic arguments, have encouraged many theists to think that other challenges to Theism in the future also can be met and make them end in failure. Theists will meet them with confidence as they did Darwinism and philosophical challenge such as Logical Positivism. Theism will prevail because the Existence of God is Truth, and an Absolute Truth.

The following facts have convinced this writer of the Existence of God.

1. The wonder of the starry sky in the night which I can observe, "Lift up your eyes on high and see Who has created these stars". (Isaiah 40:26) But, in order to see the brilliant stars, I must go to the rural area or the sea which are many miles away from the cities where the atmosphere is polluted due to innumerable cars and factories.

2. The wonder and mystery of the universe discovered by natural science.

3. God's redemptive history as testified in the Bible.

4. Miraculous healing of my 12 year old-eyes disease, which happened instantly in less than one second. I will give a detailed account of this miracle in Chapter 9 The Religious Experience of this book.

There are many features of our world (nature included) and the human experiences, which can be understood on the theistic hypothesis. Singly, they are not conclusive, but together their "cumulative effect" is very great. There is no incontrovertible evidence (or proof) of the existence of God. But the power of these

cumulative evidences is invincible. The power of these cumulative evidences is comparable with the stability of a 4 legged (or 6 legged) table. Just as these legs are mutually supportive, so these evidences are mutually supportive and convince us of the Existence of God. After I became convinced of the Existence of God, the matters of my interest and concern have changed. Whereas my concerns with moral and religious issues and social justice have increased, I have lost my interest in a ceremonial worship service at the church, my aging, my finance, socializing and sport. My philosophy of life and values has changed.

A Note to the Reader.

I remind the reader that the so-called argument from design is not the only argument to convince us of the Existence of God. There are two dozens of the theistic argument.

Hallelujah!

CHAPTER 3

The Wonder of Mathematics

Let us think about mathematics. We have learned mathematics at school (geometry, algebra, calculus and so on) and many of us may think that we know what mathematics is. However, scholarly questions like: what is mathematics? The foundation of mathematics and the principles used in mathematics and the like will be taught at the college. There are a few different theories about mathematics. Our discussion will proceed following a widely accepted theory. Mathematics is the science of expressing and studying the relationships between figures and quantities as expressed by numbers and symbols.

Mathematics was composed by abstract logical thinking of the human mind. Mathematicians can work on formulating a mathematical system in their study without having contacts with the outside-world. It is surprising that this mathematics is a very effective tool for the scientists who are engaged in the investigation of the universe (nature), that they cannot continue their scientific work without mathematics, and that scientists have found out that the universe itself has a mathematical feature.

What does this mean? It seems to mean that both the human mind and the universe have a rational character and the two match or correspond to each other in some way. We hear that it was the scientists themselves who were surprised most when they had discovered this.

Eugene Wigner, a Nobel Prize winner in the field of physics in 1965, delivered a speech on May 11ᵗʰ, 1959 at New York University and the speech was later published as a book, entitled *"The Unreasonable Effectiveness of Mathematics in the Natural Sciences"*. In the book Wigner said:

> "...the enormous usefulness of mathematics in the natural science is something bordering on the mysterious and there is no rational explanation for it".

He went on and said;

> "the miracle of the appropriateness of the language of mathematics for the formulation of the laws of physics is a wonderful gift which we neither understand nor deserve...."[1]

Wigner gave three examples as "a miracle" and said that it could be multiplied almost infinitely. One of the three was the one experienced by Albert Einstein in the development of his General Theory of Relativity and related to his effort to define a four dimensional space-time geometry. According to Wigner, Einstein realized that there was only one solution, and the solution he arrived at by his abstract mathematical reasoning precisely corresponded with the manner nature behaves, namely the manner in which the physical bodies in nature (like stars) move under the influence of each other's gravity. And it is no wonder that Einstein was deeply impressed with this correspondence between his mind and the phenomena of nature. Einstein was quoted as saying at other occasion:

> "Our experience hitherto justifies us in believing that nature is the realization of the simplest conceivable mathematical idea. I am convinced that we can discover by means of purely mathematical constructions the concepts and the laws connecting them with each other, which furnish the key to the understanding of natural phenomena. Experience

may suggest the appropriate mathematical concepts, but they most certainly cannot be deduced from it. Experience remains, of course, the sole criterion of the physical utility of a mathematical construction. But the creative principle resides in mathematics. In a certain sense, therefore, I hold it true that pure thought can grasp reality, as the Ancients dreamed."[2]

Einstein expressed repeatedly similar ideas on other occasions. His phrase above, 'pure thought can grasp reality, as the Ancients dreamed" seems to refer to what is called "the identity of being and thought" in philosophy, and this idea was taught by Plato's philosophy in ancient Greece and by Hegel's philosophy in Europe in the 19th century. To express this idea in simple words, it means that the human reason can know reality by rational reasoning without experience. This is an exaggeration, of course, but we think that it does contain some important elements of truth.

In the quotation above Einstein suggested that mathematics furnished the key to the understanding of nature. This very important notion was elaborated by John Polkinghorne, the former professor of mathematical physics at Cambridge University in Great Britain. He said:

"Firstly, the world is intelligible. This is so familiar a fact that we take it for granted. It creates the possibility of science. Again and again in physical science we find that it is the abstract structures of pure mathematics which provide the clue to understanding the world. It is a recognized *technique* in fundamental physics to seek theories which have an elegant and economical (you can say beautiful) mathematical form, in the expectation that they will prove the ones realized in nature. General relativity, the modern theory of gravitation, was invented by Einstein in just such a way. Now mathematics is the free creation of the human mind, and it is surely a surprising and significant thing that a discipline

apparently so unearthed should provide the key with which to turn the lock of the world.[3]

This physicist compared the relationship between nature (the universe) and mathematics to that between the lock and the key. We can unlock the lock with the key because the key matches the structure of the lock. Likewise physicists often discover the secrets (the law) of the universe by mathematics which is "the free creation of the human mind" in Polkinghorne's words. This indicates that there is a correspondence between the human mind and the universe and that as mathematics is rational, so is the structure of the universe.

William G. Pollard, himself a physicist, discussed in length this phenomenon of correspondence between nature and the human mind (reason) and made this remark:

> "Now we have discovered that systems spun out of the brain, for no other purpose than our sheer delight with their beauty, correspond precisely with the intricate design of the natural order which predated man and his brain. That surely is to make the discovery that man is amazingly like the designer of that order."[4]

Many scientists think that of all the scientific discoveries so far, nothing is more astonishing than the discovery that there is a relationship of correspondence between the human mind and the natural order. We need to ponder on the meaning of this discovery. This discovery not only provides us with valuable insight when we consider the nature of reality, but also strongly suggests that there is a Mind behind the universe which is similar to the human mind in some way. We will refer to this important discovery time and again in this book and call it, "the wonder of mathematics".

Our next question to consider is, How has this phenomenon of the correspondence between the human mind and the universe come to exist? We reason that it does exist because both have come from the same Mind. This is similar to the case that the key and the lock match because they came from the same locksmith. In other words, the same Mind is the common cause of the human mind and the

universe. From this we infer that the Mind behind the universe is an intelligent Mind that is similar to the human mind to some extent.

As "the wonder of mathematics" (the correspondence between the human mind and the rational character of the universe) strongly suggests that there is a Mind behind the universe, some scientists think that the existence of God has virtually been proved. John Polkinghorne is one of those scientists. He was a professor of physics at Cambridge University, but quit the job to enter a theological college as a student, and after graduation he was ordained a priest of the Church of England in 1982. He says:

> If the deep-seated congruence of the rationality present in our minds with the rationality present in the world is to find a true explanation it must surely lie in some more profound reason which is the ground of both. Such a reason would be provided by the Rationality of the Creator.[5]

In simple language, this "profound reason" is the reason of the God who created both the human beings and the world (the universe).

So far we have considered about the cause of the rational character of the universe, which is congruous with the rationality of mathematics which was spun out from the human mind. And we speculate that this universe may have a purpose.

At the beginning of this chapter we noted that there are a few different theories with respect to the question, What is mathematics? With the coming of 'new' physics, there are widely different views of mathematics and of the Universe. Recently a new line of scientific inquiry called 'chaos theory' is creating a revolutionary change in our understanding of the universe. It links our everyday experiences to the laws of nature by revealing the subtle relationships between simplicity and complexity and between orderliness and randomness. Long before the emergence of this 'chaos theory', 'quantum mechanics' delivered a devastating blow in the 1920s to the classical physics of Isaac Newton (1642-1727). The Newtonian universe worked on deterministic principles and was orderly like a clock.

Now 'new' physics does not accept a strictly deterministic view of

nature. We are told that the future states of the universe are in some sense 'open'. Some people argue that because of this 'openness' of the universe, we, the human beings can have the freedom of will and morality and live a spiritual life, and that the universe is creative and can bring forth that which is genuinely new. Here I quote the words of the physicist Paul Davies:

> It seems safe to conclude from the study of chaos that the future of the Universe is not irredeemably fixed. The final chapter of the great cosmic book has yet to be written.[6]

Paul Davies and another renowned physicist John Gribbin published as co-authors in 1992 a book titled *"THE MATTER MYTH"*, *Dramatic Discoveries that Challenge Our Understanding of Physical Reality.*

In the Preface of the book the co-authors said:

> The word 'revolution' is rather overworked in science. Nevertheless, even those people with merely a casual interest in matters scientific will be aware that some truly revolutionary changes are currently taking place. We refer not so much to the specific discoveries that are happening all the time, nor to the many wonderful advances in technology. True, these changes are revolutionary enough in themselves. There is, however, a far more profound transformation taking place in the underlying science itself – in the way that scientists view their world...... Our intention is to provide a glimpse of the new universe that is emerging. It is a picture still tantalizingly incomplete, yet compelling enough from what can already be discerned. We have no doubt that the revolution which we are immensely privileged and fortunate to be witnessing at firsthand will forever alter humankind's view of the Universe.[7]

We assume that Paul Davies and other scientists are not exaggerating, but are telling what they believe to be true. If this is the case, it appears that what I remarked about mathematics and the human mind and about the universe in the foregoing may need some revision.

The 'picture' of the universe described by the scientists is astonishing indeed. But this 'picture' of the universe is incomplete and provisional since the scientists themselves have not grasped the true reality of this universe yet. Not yet. The picture may change in the years ahead; it is even likely to change. The so-called "chaos theory" has brought a revolutionary change in the traditional understanding of the universe, not only of the scientists, but also of the general population, because the traditional understanding of the universe was that the universe is orderly, and not chaotic or random.

We cannot exclude the possibility that additional revolutionary scientific discoveries will be made in the future, causing further changes in the scientists' view of the universe. We have seen that quantum mechanics has replaced the classical physics. Similar replacements will happen in the history of science.

The 'picture' of the universe being described by scientists at the present stage is astonishing enough. Here we feel that the universe is not only astonishing, it is also mysterious. Then, how much more astonishing and mysterious the God will be, who has brought this universe into existence!

In the new physics, some scientists say that there are chaos and randomness in the universe. This feature of the universe is a surprise to us because we had been told that the universe is orderly and has a rational feature like mathematics. But I emphasize that this is not the final word of the new physics about the universe. As Paul Davies admitted, the scientists' grasp of the universe is incomplete. I am optimistic and hopeful that they will be surprised by new scientific discoveries about the more profound truths of the universe in the future. This is because I am convinced that this universe was created by God. Chaos and randomness cannot be the main feature of the universe created by God. If some chaos is observed anywhere in the universe, it would be for an important purpose unknown to us today, but will be known tomorrow. I explain my point by an illustration. It is like the case that because of the indeterministic feature of nature

"the free will and moral life of the human beings" are possible and we can lead a worthy spiritual life. The indeterministic feature of nature means that there is "openness" in nature. Because of this "openness" we, human beings can exercise freedom and can be creative. Creativeness means that we can create something new. So there is the progress of the civilization of mankind.

Whatever some of the scientists may say today, we can rest assured that this amazing universe created by God will not disappoint us.

CHAPTER 4

The Anthropic Principle in Cosmology

It is not hard to comprehend that the emergence of life and the survival of the living things in nature necessitate the fitness of the natural environment. By the natural environment here we do not only mean the local environment in which living things live, but also the environment on the earth and the condition of the solar system. I give examples.

Could the living things emerge on the earth if there were no sun? Not likely. Let us think about the distance between the sun and the earth. Even if the sun exists, if the distance between the sun and the earth were 20 times greater than it is now, the temperature of the earth will be too low for the emergence of life and the survival of living things. At least the human beings as we know them will not be able to survive. Contrarily, if the distance were 20 times shorter, then the temperature on the earth will be too hot and probably no living things will be able to survive and fare well.

We are told by some scientists that life first emerged on the earth hundreds of million years ago and gradually evolved ever since. We assume that this was possible because the distance between the sun and our earth was just about right. The question of the distance is merely one simple example, and many other kinds of fitness are required for the appearance and survival of living things on the earth.

Through the progress of cosmology and astro-physics during the past few decades, a new scientific discovery was made, namely, that

for the emergence of life and its evolution leading up to the human species a delicate balance in the structure of the fundamental forces and (perhaps) the special initial circumstances of the universe were required, besides the fitness of the environment on the earth and in the solar system

According to the contemporary cosmology, the universe originated from the Big Bang which happened some 14-15 billion years ago. The term "the Big Bang" refers to the earliest event in the universe's history accessible to science: that singular moment in which the cosmic matter appears to have exploded from a point of infinite compression. The Big Bang theory is a hypothetical account for the formation of the universe by an explosion 14-15 billion years ago. We are told that for the delicate balance of the fundamental forces of the universe which is required for the emergence and survival of living things, the fundamental forces have to be related to one another in just about the way that we actually find them to be. For these scientific information this writer is indebted to the physicists John Polkinghorne's work *One World (1986)* and Paul Davies' work *God & the New Physics (1983)*.

In the early expansion of the universe after the Big Bang, there had to be a balance between the expansive force (driving things apart) and the force of gravity (pulling things together). If expansion dominated, then cosmic materials would have flied apart too rapidly in all directions for condensation into galaxies and stars to take place. And nothing interesting could then happen. On the other hand, if gravity dominated, materials had to be pulled back and the cosmos would have collapsed before there was time for the process of life starts. For humans to emerge, it required a balance between the effect of expansion and that of contraction, which at the earliest moment in the universe's history differs from equality by not more than 1 in 10^{60}. The number 10^{60} is 10 with 60 zeroes after it. This is a staggering accuracy.

In other words, if the explosion had differed in strength at the outset by only one in 10^{60}, the universe we now see would not exist. To give some meaning to these numbers, Davies uses an illustration.[1] Suppose you wanted to fire a bullet at a one-inch target on the other side of the observable universe 20 billion light-years away. In order to hit the target your aim would have to be accurate to the same one

in 10^{60}. A light-year is a unit of length in interstellar astronomy equal to the distance that light travels in one year in a vacuum or about 5,878,000,000,000 miles. It takes about 8 minutes for the light of the Sun to reach the earth.

Apart from the accuracy of this overall balance, there is the mystery of why the universe is so extraordinarily orderly. Through our common experience, we know that most explosions are chaotic in its outcome. Accordingly the highly orderly nature of the universe on such a large scale might be interpreted as an evidence of the existence of the Divine Creator.

Theists can accept the Big Bang theory. Theism and the Big Bang theory are not incompatible. However, Theism can be compatible with some other explanations regarding the origin of the universe. There can be alternative explanations compatible with Theism. In other words, the Big Bang theory is not the only theory regarding the emergence of the universe that is compatible with Theism. Therefore, even if the Big Bang theory turns out to be false in the future, theists will not be disheartened by it. And the truth of Theism will not be affected by it. Some other better explanation about the origin of the universe will be found. Truth remains truth whatever the trend of scientific theory and of human thought may be.

We now turn to our next theme. Sir Denys Wilkinson, a former professor of nuclear physics and experimental physics at Oxford University, has been deeply impressed by an astounding fit between us the humans and the universe, and he wrote:

> "There is an astounding goodness of fit between us and our own Universe. If, as I shall relate, the Universe had been only slightly different in any of many ways to do with the laws and constants of Nature and to do with the properties of the substances to which those laws give rise, we would not be here to wonder at it; our existence seems to be due to the delicate interplay of a large number of individually incredible accidents. This bundle of considerations goes under the general heading of the anthropic principle, which has been developed in a multiplicity of forms by Brandon Carter, Robert

31

Dicke, and many others. I will not attempt to survey this ramification of forms but just state the principle in the crudest possible way: our Universe has to be as it is because if it were not, then we would not be here".[2]

Wilkinson mentions "the Anthropic Principle" which refers to a chain of incredible coincidences which produced the natural environment necessary for the appearance and survival of living things including the human beings. Wilkinson gave a catalog of 23 lucky coincidences which make nature fit for us, human beings. They include chemistry, planets, time scale and evolution, the rule of law, dimensions, the neutron-proton mass relationship, the weak interaction, neutrino species, the nuclear force, complex nuclei, the fine structure constant, the temperature of the stars, the lifetime of the stars, the density of the universe, the value of the cosmological constant, the formation of atoms, galaxy formation,

After discussing each of these Wilkinson asks: "what should we make of this remarkable catalog of coincidences?" This is a question many of us would ask. There may be a number of explanations of these coincidences. But it seems to this writer that in the final analysis there are only two diametrically opposed explanations. The first is the teleological explanation which promotes the concept of the anthropic principle, namely, that God intentionally created the universe in such a way that we, humans might come into existence in it. To express it differently, in the beginning of the universe God made the laws and the constants as they are so that we might be here. In the words of Fred Hoyle, another distinguished physicist, "the Universe is a put-up job".

The second explanation is that the universe and everything in it came to exist by accident, with no intelligence or will involved. In our view it is irrational to accept such an explanation. Wilkinson says,

"We have to accept that our Universe, as a whole, is just right for us in a large number of independent and tightly constrained ways."[3]

This scientific discovery is an extraordinary event and we think

that it has a profound significance not only from the scientific perspective, but also from the religious and philosophical perspective. Its significance is, in our judgment, as great as the significance of what we call "the wonder of mathematics". Both discoveries will further encourage the theistic explanation of the emergence of the universe and the human beings and will strengthen Theism itself. An astronomer John D. Barrow and a physicist Frank J. Tipler worked together and produced a voluminous book (706 pages) on the anthropic principle (in 1986), titled *The ANTHROPIC COSMOLOGICAL PRINCIPLE*. The book which is the result of extensive research, presents a clear exposition of the anthropic principle, and has made a contribution for the propagation of the idea.

The word "anthropic" is derived from a Greek word 'anthropos' which means "man"; apparently those scientists who coined the term "anthropic principle" wished to convey the idea that the universe is to be understood athropo-centrically, namely, that the universe is constructed in such a way as to advance the emergence, survival and prosperity of the human beings.

Regarding the non-theistic explanation that this astonishing universe came to exist by blind chance with no intelligent mind involved, we maintain that to accept such an explanation will take an enormous leap of belief and is not rational. It would be difficult for a rational person to believe that a large number of independent coincidences happened by accident. I explain my point by an illustration.

In our society there is what is called a lottery. Let us suppose that here is a lottery in the amount of ten million dollars, and a large number of men and women bought the ticket in the hope of winning. Everybody knows that it is not easy to win a lottery. Actually it is very difficult to win. Nevertheless, no matter how difficult it may be, there is usually someone who wins. The winner wins it by good luck. However, there is a limitation in good luck. For example, have you seen or heard of a lucky person who had won 10,000 lotteries in succession without a single failure? In theory it would be possible to win 10,000 lotteries in succession. In practice, however, it would be extremely difficult and improbable that one person wins 10,000 lotteries in succession. I have not heard yet that there was such a lucky person anywhere in the world. Have you?

Now it appears that to say that a large number of cosmological coincidences we have discussed above, did happen by accident, or that this marvelous universe came into existence by accident, is like saying that it is very probable in reality for a person to win a lottery 10,000 times in succession. We would not regard anyone who says so as a rational person. Likewise we would not think that anyone who says that this amazing universe came to exist by accident without any intelligent mind involved, is a rational person. Accordingly we do not think that Atheism is a rational and credible worldview.

This second interpretation of the 23 happy coincidences in the universe which enabled the emergence and prosperity of the human beings and other living things, is saying, in effect, that the 23 coincidences happened by accident. If we can reasonably reject this second interpretation, then we would be justified in entertaining the anthropo-centric interpretation of the universe (which the "anthropic principle" endorses implicitly) and in holding the theistic worldview. The theistic worldview in the present context is that God created the universe with these felicitous coincidences for the purpose of making the earth which is a part of the universe, the home, so to speak, for the human beings and other living things. This purpose would be a part of God's grand purpose in creating the universe. However, the mere physical life of the human beings will not be very worthwhile. There must be a moral and spiritual purpose. We will discuss this question later.

Paul Davies quoted from the scientist Ralph Estling's article on the anthropic principle and printed it in his book *Superforce* (p.238),

> Underlying the argument for the supernatural or the super-intelligent is the anthropic principle, the realization the Universe is so exactly the right kind of Universe for man that we must meditate on the thousands of coincidences that are absolutely essential for man, or indeed for life to exist. One slight variation in just one of those thousands of essential coincidences would have altered the physical Universe drastically, possibly totally. Yet down to the fine structure constants that dictate

gravitational, electromagnetic, and strong and weak nuclear forces, and up to basic biological prerequisites, we find the cosmos in general, our Sun in particular, and Earth most particularly, so minutely attuned to us, that the conclusion seems inescapable: God or someone else of the same name made it like that, with us in mind. It is, we insist, just too much of a coincidence, just too much of a miracle, to say it is pure, unnecessitated chance.

Here we have to consider an important question: Can we say that the existence of God is being proved by the wonders of mathematics, the anthropic principle and other scientific discoveries? I mentioned earlier that some scientists think that God's existence has practically been proved. If I consider the illustration of lottery above, I feel like to agree with them. However, there is another important question I have to think about carefully.

Let us recall what we have discussed earlier. If God is a "transcendent" being infinitely beyond the universe and the humans, it would be impossible to prove God's existence directly from the universe and the human experience. What the wonder of mathematics and the anthropic principle prove is not that God exists, but that a Mind which is similar to the human mind to some extent exists behind, or behind and in the universe. I might call this Mind a Cosmic Mind. It is reasonable and believable to identify this Mind with God.

"The wonder of mathematics" and the anthropic principle are two of the cosmological phenomena which are related with mathematics. In the following chapters I will deal with other features of the universe which are not related with mathematics, and yet suggest the existence of a Mind behind the universe.

CHAPTER 5

The Natural Theology of Hume and Kant

An infinite difference between God the Creator and the creatures was emphasized by the philosophers David Hume (1711-76) and Immanuel Kant (1724-1804). And they also called attention to the epistemological limit of the human reason, namely, that there is a limit beyond which the human reason cannot know.

Assuming that the teaching of Hume and Kant in this respect is valid, the theists will have to find other method in their argument for the existence of God. It seems that there are two methods that we, the theists, can utilize. The first method is that, giving up the attempt to prove God's existence directly from the phenomena of the universe, we try an indirect method, namely, that we "infer" God's existence from the universe and its astonishing phenomena. For instance, we will try first to demonstrate on the basis of the amazing phenomena of the universe such as the wonder of the mathematics, the anthropic principle and so on, that there is a Mind behind the universe and then propose to identify this Mind with God. This is not a proof of God's existence, but only an inference of it.

The second method that the theist may use is a hypothetical argument. It proposes to make (set up) a hypothesis that God exists, and examine if this hypothesis can explain the universe and the human experience more adequately, and examine also if this theistic hypothesis can, at least, explain them better than Atheism does.

In the history of natural theology David Hume (an Englishman)

and Immanuel Kant (a German) hold prominent places and have exerted a rather negative influence, and their influence is still being felt today. It has been maintained by some that Hume and Kant have dealt a mortal blow to natural theology or even that natural theology was buried by Hume and Kant.

However, this is an exaggeration or a misunderstanding. We wonder if those who make such an assertion have read Hume's principal work *Dialogues Concerning Natural Religion* and Kant's *Critique of Pure Reason*. Those who have read these celebrated books carefully will not dare to make such careless and irresponsible remarks. Shame on them! We would like to explain why we say so. To do this, we need to discuss Hume's and Kant's philosophy at some length. To discuss and assess their theories is not only necessary, but also beneficial.

Criticism by Hume and Kant

Hume wrote a controversial work *Dialogues Concerning Natural Religion* which criticized the argument from design, but did not publish it during his lifetime as he was afraid of the persecution from the religious establishment of his day. Hume arranged a posthumous publication of the book and died at the age of 65. His book was published in 1779. In the 18th century Britain the institutional religion had a great power. Hume's intention in writing this book was not to advocate Atheism but to argue, according to the prevailing opinion among scholars, that "natural theology" which purports to prove the existence of God failed as a proof. Hume called in question the validity of the analogical reasoning which was usually used by the theistic writers in the 18th century Britain. He also pointed out the limit and frailty of the human reason, especially when it deals with the origin of the universe and the questions related to God who is infinite and transcendent. He expressed skepticism about man's ability to know the existence and nature of God. Hume also questioned the possibility of metaphysics. He spoke about 'agnosticism' in his earlier works and in *Dialogues Concerning Natural Religion* repeatedly. Hume put these words into the mouth of Philo who is one of the three participants in the dialogue.

"Let us become thoroughly sensible of the weakness,

blindness, and narrow limits of human reason: Let us duly consider its uncertainty and needless contrarieties, even in subjects of common life and practice. Let the errors and deceits of our very senses be set before us; the insuperable difficulties which attend first principles in all systems; the contradictions which adhere to the very ideas of matter, cause and effect, extension, space, time, motion;....When these topics are displayed in their full light, who can retain such confidence in this frail faculty of reason as to pay any regard to its determinations in points so sublime, so abstruse, so remote from common life and experience? ...With what assurance can we decide concerning the origin of worlds, or trace their history from eternity to eternity?"[1]

"When we carry our speculations into two eternities; into the creation and formation of the universe; the powers and operations of one universal Spirit, existing without beginning and without end; omnipotent, omniscient, immutable, infinite and incomprehensible, we have here got quite beyond the reach of our faculties".[2]

So we can see why Hume was skeptical and critical of the philosophers and theologians who claimed that they can prove the existence of God and that they know pretty much about God. The Scottish philosopher Norman Kerup Smith who is known as an expert on Hume's philosophy said:

"Hume is not questioning the belief in God. Hume attacks not theism, but superstition and idolatry; he questions not the existence of God but only the mistaken argument for such existence, and the unworthy modes of conception in which they result".[3]

Let's hear Hume's own words again put into the mouth of Philo:

> "Nor would any of human race merit God's favour, but a very few, the philosophical theists, who entertain, or rather indeed endeavor to entertain, suitable notion of His divine perfections. As the only persons entitled to His compassion and indulgence would be the philosophical skeptics, a sect almost equally rare, who from a natural diffidence of their own capacity, suspend, or endeavor to suspend all judgment with regard to such sublime and such extraordinary subjects".[4]

Because of such skepticism, Hume is known as a skeptic in philosophy. One of the founders of a philosophical tradition which is called the British empiricist school of philosophy, Hume exerted a lasting influence in the Western philosophy. Hume launched a sustained offensive against all supposed theistic proofs of natural theology.

Hume also directed his attack on the institutional religion and the professional clergymen as well as the superstition of people. He applied for the position of the professor of philosophy in the university a few times; but due to the opposition of the clergymen he failed in his attempt again and again. As the result Hume became even more critical of the clergy. He held that most of the religious doctrines taught by the institutional religion is superstition. He distinguished Theism from the institutional religion and the popular religion, and equated the latter two. He ridiculed the superstition and fanaticism of the popular religion. For Hume Theism is not merely a religious belief, it is also a philosophical thought. He considered the existence of God as a philosophical question and let Philo speak about 'philosophical theism'. Hume did not believe that God intervenes in the affairs of the world or performs a miracle.

According to the philosopher J. C. A. Gaskin who authored a book entitled *Hume's Philosophy of Religion* (1978), Hume entertained a "deistic" concept of God. Deism is a doctrine that God is the Creator of the universe; but once the process of creation has been completed God leaves it to run according to its laws, and does not intervene. This doctrine is sometimes referred to as the "absentee landlord" view. Such a view of God is clearly different from the Europeans' traditional belief about God.

There is some ambiguity in Hume's concept of God and in his attitude toward natural theology. In *Dialogues Concerning Natural Religion* Hume let Philo make a number of critical comments on natural theology, but in the latter part of the book Philo suddenly changed his position and acknowledges some possibility of natural theology and natural knowledge of God. Philo said:

> "the cause or causes of order in the universe probably bear some remote analogy to human intelligence; and the arguments on which natural theology is established, exceed the objections which lie against it".[5]

So Hume does not deny the possibility of natural theology and of natural knowledge of God. Hume puts even these words into the mouth of Philo:

> "But surely, where reasonable men treat these subjects, the question can never be concerning the being of the Deity, but only the nature of the Deity. The former truth, as you well observe, is unquestionable and self-evident".[6]

The awesome magnificence of the universe being what it is, for Hume the existence of God is self-evident and unquestionable. However, man's natural knowledge of the nature of God, His attributes, His will and His plan of providence is minimal and it is subject to uncertainty and disputation. Philo maintains repeatedly that these extraordinary questions are beyond the capacity of the human reason; and he says:

> "The most natural sentiment, which a well-disposed mind will feel on this occasion, is a longing desire and expectation, that Heaven would be pleased to dissipate, at least alleviate, this profound ignorance, by affording some particular revelation to mankind, and making discoveries of the nature, attributes, and operations of the divine object of our Faith. A person, seasoned with a just sense of the

imperfections of natural reason, will fly to revealed truth with greatest avidity".[7]

What is particularly interesting and significant is the comment made by the person who was attentively listening to the debate of the three participants. He said:

"I confess that, upon a serious review of the whole, I cannot but think that Philo's principles are more probable than Demea's; but that those of Cleanthes' approach still nearer to the truth".

This is the last sentence of Hume's *Dialogues Concerning Natural Religion.* In this book Philo is a skeptic, Demea a rigid orthodox and Cleanthes a natural theologian. So this indicates that Hume does not deny the possibility of natural theology.

Here we turn to the philosopher Kant's position with respect to natural theology. Many scholars are of the opinion that Kant's position is by and large similar to Hume's. Kant is 13 years younger than Hume and acknowledged that he is indebted to Hume in epistemology. Epistemology is one of the major components of philosophy which occupies itself with the study of the nature and origin of man's knowledge, especially with respect to its limits and validity. Two years after Hume's *Dialogues Concerning Natural Religion* was published posthumously, Kant published his own monumental work *Critique of Pure Reason* (1781). Kant's fundamental proposition in this book is that the subjects which have traditionally been dealt with by metaphysics and natural theology transcend the powers of human reason; hence metaphysics and natural theology are illegitimate.

Kant reached this negative verdict on the basis of his epistemology which is presented in his *Critique of Pure Reason.* Kant's arguments are dense and complex, but the gist of his argument as relevant to our concern in this book, namely the possibility and validity of natural theology, is as follows. There are two sources of human knowledge: sensibility and understanding, "Through our sensibility (eye, ear, nose etc.) objects are given to us, and through understanding they are thought". Kant explains what he means by "understanding" here.

It is "the mind's power of producing representations from itself", or "the faculty which enables us to think the object of sensible intuition". It is through the workings of understanding that sensible experience comes to be ordered and classified into experience of the objective world (the world of nature), thus constituting our knowledge of things and our thought. But God is not an object of our sense experience and 'the categories of understanding' are restricted in their application to the phenomena encountered in space and time, and as such are not applicable to a transcendent reality like God. Accordingly there is no way for human reason to know anything about God, His existence and His nature. Human reason has no means of discovering facts outside the realm of sense experience.

Kant directed his criticism especially at metaphysics which was once respected as the queen of all sciences and he rejected metaphysics as merely dogmatic speculation of human reason. We have seen that Hume rejected metaphysics for the same reason. Some philosophers have used the term metaphysics somewhat in a different sense; but for Kant metaphysics was a vain speculation about subjects which are far beyond the power of human reason – subject such as the Ultimate Reality as existing in itself apart from the illusory speculation of human reason.

As metaphysics was highly respected in 18th century Europe, Kant's *Critique of Pure Reason* which made such negative verdict on metaphysics gave a shock to the religious world as well as to philosophers and theologians. Since Kant was already a respected philosopher in his lifetime, the influence of his critical philosophy quickly spread in Europe.

Thus, not only speculative metaphysics but also natural theology which attempted to prove the existence of God suffered a severe blow. Some people took this setback of natural theology as meaning the victory of Atheism or an endorsement of Atheism. But this is a misunderstanding of the case. Neither Hume nor Kant was an atheist. And their criticism of natural theology was not motivated by a desire to promote Atheism. Kant even proposed a new kind of proof of God's existence, namely, the existence of God as the moral demand. Kant made this remark about the usefulness of natural theology:

"Although reason, in its merely speculative employment, is very far from being equal to so great an undertaking, namely, to demonstrate the existence of a Supreme Being, it is yet of very great utility in correcting any knowledge of this Being which may be derived from other sources and in ….."[8]

He also said:

"The same grounds which have enabled us to demonstrate the inability of human reason to prove the existence of a Super Being must also suffice to prove the invalidity of all counter assertions. For from what source could we, through a purely speculative employment of reason, derive the knowledge that there is no Supreme Being as ultimate ground of all things?"[9]

As 'counter assertions' to Theism, Kant listed Atheism, deism and anthropomorphism.

Kant did not marry and devoted his whole life to the study and teaching of philosophy. Hume was the same in this respect.

As Hume and Kant raised serious difficulties for the traditional theistic proofs, those who attempt to undertake natural theology today cannot ignore the work of Hume and Kant completely.

As we saw in the foregoing, Hume did not reject natural theology totally. He left a little room for natural theology. Kant too emphasized the impossibility of the proof of God, but he had a great respect for what he called 'the physico-theological proof', which is by and large equivalent to what is nowadays called the "argument from design" or the "teleological argument". He gave four chief points of his physico-theological proof, of which three points are:

1. In this world we everywhere find clear signs of an order in accordance with a determinate purpose, carried out with great wisdom; and this in a universe which is indescribably varied in content and unlimited in extent.

2. This purposive order is quite alien to the things of the world, and only belongs to them contingently; that is to say, the diverse things could not of themselves have cooperated, by so great a combination of diverse means, to the fulfillment of determinate final purposes, if they had not been chosen and designed for these purposes by an ordering rational principle in conformity with underlying ideas.

3. There exists, therefore, a sublime and wise cause, which must be the cause of the world not merely as a blindly working all-powerful nature, but as intelligence through freedom.[10]

Kant made this statement with regard to the proof of God from design. I quote:

"This proof always deserves to be mentioned with respect. It is the oldest, the cleverest, and the most accordant with the common reason of mankind.

...This knowledge so strengthens the belief in a supreme Author (of nature) that the belief acquires the force of an irresistible conviction. It would therefore not only be uncomforting but utterly vain to attempt to diminish in any way the authority of this argument. Reason, constantly upheld by this ever – increasing evidence, is aroused at once from the indecision of all melancholy reflection, or from a dream, by one glance at the wonders of nature and the majesty of the universe – ascending from height to height up to the all – highest, from the conditioned to its conditions, up to the supreme and unconditioned Author (of all conditioned beings)".[11]

It is interesting to note that Hume made an essentially similar remark through Philo in the *Dialogues Concerning Natural Religion*. I quote again:

"In many views of the universe, and of its parts,

particularly the latter, the beauty and fitness of final causes strike us with such irresistible force, that all objections appear mere cavils and sophisms; nor can we then imagine how it was ever possible for us to repose any weight on them".

And Kant elaborated what he described as 'the wonders of nature and the majesty of the universe':

> This world presents to us so immeasurable a stage of variety, order, purposiveness, and beauty, as displayed alike in its infinite extent and in the unlimited divisibility of its parts, that even with such knowledge as our weak understanding can acquire of it, we are brought to face to face with so many marvels immeasurably great, that all speech loses its force, all numbers their power to measure, our thoughts themselves all definiteness, and that judgment of the whole resolves itself into an amazement which is speechless, and only the more eloquent on that account. Everywhere we see a chain of effects and causes, of ends and means, a regularity in origination and dissolution. Nothing has of itself come into the condition which we find it to exist, but always points to something else as its cause, while this in turn commits us to repetition of the same enquiry. The whole universe must thus sink into the abyss of nothingness, unless, over and above this infinite chain of contingencies, we assume something to support it – something which is original and independently self- subsistent, and which as the cause of the origin of the universe secures also at the same time its continuance. What magnitude are we to ascribe to this supreme cause – admitting that it is supreme in respect of all things in the world? We are not acquainted with the whole content of the world, still less do we know how to estimate its magnitude by comparison with all that

is possible. But since we cannot, as regards causality, dispense with an ultimate and Supreme Being, what is there to prevent us ascribing to it a degree of perfection that sets it above everything else that is possible?[12]

In the quotation above Kant said that our knowledge of nature through its study "so strengthens the belief in a supreme Author (of nature) that the belief acquires the force of an irresistible conviction".

Then, is he saying in effect that it is possible to prove the existence of God through the evidence of design as manifested in the phenomena of the universe? It is not what he means to say. Kant has already, on the ground of his epistemology, stated that it is impossible for man to prove God's existence. He is saying in effect that although we cannot prove the existence of God, our belief in God's existence is not blind or absurd, but rather reasonable and rationally defensible. There is a convincing ground for this belief. However, to be convinced of God's existence is still a belief, rather than certain knowledge. (Actually this is the position of many theists.) Regarding one's arriving at an irresistible conviction of God's existence through the observation of nature and evidences of design, Kant had this to say:

"Although we have nothing to bring against the rationality and utility of this procedure, but have rather to commend and to further it, we still cannot approve the claims, which this mode of argument would fain advance, to apodeictic certainty and to an assent founded on no special favour or support from other quarters".[13]

'Apodeictic' certainty means absolute certainty.

As I mentioned earlier, the theistic argument for God's existence from the phenomena of nature is an analogical argument. Paley's argument from a watch is a good example. We recall Paley's reasoning that as the structure and functions of the parts of a watch suggest the existence of a watch maker who designed it, so the marvelous construction of an eye and of the bird's and butterfly's wings suggest

the existence of a master-craftsman who had made the organs of the living organism superbly adapted for the function which they were designed to perform. And if the universe reveals the mechanical regularity of a watch which keeps perfect time, the existence of a divine watchmaker is to be inferred.

On this kind of theistic argument Kant made this comment:

> "The utmost that the argument can prove is an architect of the world who is always hampered by the adaptability of the material in which he works, not a creator of the world."[14]

Kant acknowledged that there is so much in nature which suggests a purposiveness and design as in the case of the man-made things (such as a watch, a car, a house and a ship), that it is reasonable to infer the existence of 'an architect'. Yet Kant could not equate the architect with the Creator of the world.

I would like to remind the reader of a thesis I presented in Part One of this book. There I discussed the wonder of mathematics (chapter 3), the anthropic cosmological principle (chapter 4); and I inferred from these the existence of a Mind behind the universe. But I did not equate this cosmic Mind with God. I was inclined to equate the two, but I stopped short of doing so. The identity of the two has a very high probability but there is no absolute certainty. I presume that Kant made his distinction between the architect and the Creator of the world with a similar consideration.

I infer the existence of a Mind behind the universe (Kant inferred the architect of the world) on sufficient grounds. This means that natural theology is neither futile nor dead even after Hume and Kant. The allegation made by some scholars that natural theology was "buried" by Hume and Kant is not merely an unfounded exaggeration, it is also untrue. Kant admitted that the theistic argument from nature as done by natural theology cannot claim absolute certainty of God's existence. Yet he said: "we have nothing to bring against the rationality and utility of this procedure, but have rather to commend and further it". He also said: "This proof always deserves to be mentioned with respect…. It enlivens the study of nature; just as it itself derives its existence and gains ever new vigour from that source".

What does Kant have in mind when he recognizes "the rationality and utility" of this argument from apparent design and purposiveness in nature? By the word 'utility' he seems to be saying that although this argument falls short of being a proof of God in the strict sense of the word, it is not useless. It may not create a belief in God in the mind of a stubborn atheist, but some believing individuals will find a value in it because the rationality of the argument provides a boost when their belief in God falters.

And, of course, the argument from design and purposiveness in nature is not the only theistic argument. Besides, there are the ontological argument, the cosmological argument, the argument from nature's beauty and sublimity, the argument from the moral experience, the argument from the religious experience and more. The argument from design, together with these arguments, constitute "a cumulative case for the Existence of God".

Regarding the utility of the theistic arguments, the philosopher Karl Jaspers (1883-1969) expressed his view.

> The arguments for the existence of God do not lose their validity as ideas because they have lost their power to prove. They amount to a confirmation of faith by intellectual operations.[15]

In our view it does not take an extraordinary intellect and insight to recognize the rationality and validity of the theistic argument (natural theology). The common sense of ordinary people will enable them to do so.

Kant had a great respect for natural science. But in the 18th century in which he lived natural science was at an early stage of progress and the scientific knowledge of nature was very limited. Nevertheless Kant said: "This knowledge…so strengthens the belief in a supreme Author of nature that the belief acquires the force of an irresistible conviction." Had Kant lived in the 21st century and had the degree of scientific knowledge of nature that we have as available through today's natural science, what would Kant's assessment of natural theology be? Some scholars are of the opinion that in that case Kant would make a more positive assessment of natural theology and have an even greater conviction about the existence of God.

And probably it would be the case with Hume as well, judging from the words he put into the mouth of Philo. I quote them again:

> "In many views of the universe, and of its parts, particularly the latter, the beauty and fitness of final causes strike us with such irresistible force, that all objections appear (what I believe they really are) mere cavils and sophisms; nor can we then imagine how it was ever possible to repose any weight on them".

> "...the inexplicable contrivance and artifice of nature. A purpose, an intention, or design strikes everywhere the most careless, the most stupid thinker; and no man can be so hardened in absurd systems, as at all times to reject it".

'The wonder of mathematics' and the anthropic cosmological principle as well which we have discussed in the opening chapters of this book are scientific knowledge acquired through the study of nature, and this knowledge has converted many atheists to Theism and strengthened many individuals' belief in God.

As we saw already, both Hume and Kant were well aware of the limit of the human reason when it comes to deal with metaphysical questions such as the nature of the ultimate reality and the existence of God, and emphasized it repeatedly. Hume also discussed through Philo the question of the suffering and misery in the world and admitted that they are seemingly incompatible with the infinite power, infinite wisdom and infinite goodness of God. Yet this did not make him an atheist, but he said that these subjects exceed all human capacity, and that our common measure of truth and falsehood are not applicable to them.

And Hume thinks that man cannot know the nature and attributes of Deity from the phenomena of nature or from the human experience, and that to obtain this knowledge man needs to be favoured with some divine revelation. We touched on this point earlier. We are impressed with the epistemological humility of these two great philosophers.

Kant said that the knowledge of nature gained from 'the study

of nature' "so strengthens the belief in a supreme Author of nature that the belief acquires the force of an irresistible conviction". "The study of nature" would include both the observation of nature which any interested person can do and the scientific research conducted by scientists. And the knowledge of nature which "strengthens the belief in the supreme Author of nature" will be various in kind, numerous in number and broad in scope. In our humble view, however, what we call "the wonder of mathematics" and "the anthropic cosmological principle" are among the most noteworthy so far although we acknowledge the possibility and even the probability that in the future comparable or even more astounding new scientific discoveries will be made. For now I propose to pay attention briefly to the anthropic cosmological principle again.

For human beings and other living organisms to emerge and to survive in nature, a suitable natural environment needed to be prepared. And for the suitable environment to emerge and remain stable a number of cosmological conditions had to be provided and other requirements be met. We saw already in chapter 4 that the universe has to be as it is in order for life to emerge and survive, which depends on a large number of extraordinary coincidence. The anthropic cosmological principle refers to this amazing situation. About this situation the physicist Paul Davies said:

> The sheer improbability that these felicitous concurrences could be the result of a series of exceptionally lucky accidents has promoted many scientists to agree with Fred Hoyle's pronouncement that 'the universe is a put-up job'.[16]

Davies gave eight more remarkable phenomena of the universe besides the anthropic principle and said:

> Physics is full of such examples of ingenuity and subtlety, and one could fill volumes discussing them,... Nature is very, very cleaver indeed.[17]

And Davies asks: "Who can fail to be struck by the ingenuity of the natural world?" I quote him further:

A common reaction among physicists to remarkable discoveries of the sort discussed above is mixture of delight of the subtlety and elegance of nature, and of stupefaction: 'I would never have thought of doing it that way'. If nature is so clever it can exploit mechanisms that amaze us with their ingenuity, is that not persuasive evidence for the existence of intelligent design behind the physical universe? If the world's finest minds can unravel only with difficulty the deeper workings of nature, how could it be supposed that those workings are merely a mindless accident, a product of blind chance?[18]

When we listen to such testimonies of scientists regarding the wondrous features of nature, we feel like to agree to Kant's remark quoted earlier. And the opinion expressed by many scholars seems right, namely, that the result of modern science so far is very disadvantageous to Atheism and advantageous to Theism. It is extremely significant that whereas new scientific facts have been discovered unceasingly since the 17th century which suggest the existence of a Mind behind nature, no scientific discovery has been made which favors the atheistic view that the universe and all the phenomena in it are the product of blind accident.

The recent development in the world of philosophy too is significant. We are delighted to hear that a philosophical school called Logical Positivism which has been tormenting the theists with a proposition that theistic doctrines and metaphysics are 'meaningless', has collapsed due to its internal self-contradiction. Logical Positivists held that all genuine knowledge must be confined to the experimental sciences. Any statement which cannot be tested and verified by science whether it is true or false, is meaningless and it is not real knowledge. The existence of God, the creation of the world, the nature of reality, etc. which cannot be tested and verified by science, are neither true or false, but simply meaningless. This is the Logical Positivists' basic argument. Truths pertaining to theology and metaphysics cannot be tested and verified by science; therefore these truths are simply meaningless according to Logical Positivism. Wherefore, theological doctrines, also along with metaphysics, are

meaningless according to Logical Positivism. But Logical Positivism is now being discredited. Regarding this development Keith Ward, a philosopher of Oxford University has this to say:

> My own estimate of the present position in English-speaking philosophy is that we have moved out of the phase in which metaphysics was thought to be impossible in principle. It is generally accepted that Logical Positivism was itself a very odd metaphysical views; and it is now scarcely even maintained in public,........ The way is open for a metaphysical doctrine of God, if we can find a satisfactory one.[19]

There is another interesting development which is taking place in science. It is that new physics is coming near to metaphysics and physicists themselves are becoming metaphysicians. The distinguished nuclear physicist Sir Denys Wilkinson whom I introduced earlier said:

> Physicists have led themselves into an arena more commonly thought of as that of the philosopher – and the metaphysician at that. But they must not be afraid of it; they have been led there by their understanding of the firmly based natural world of their own experience and have not cooked it up *abs initio* on the basis of ideas that are not themselves part of a verifiable natural system,.... Metaphysics, which the physicist, through his very physics, is now taking on board, is back in.[20]

I regret that I cannot elaborate on this significant development in philosophy. Here we return to the subject which is our main concern.

As indicated already, the theistic argument from design is, in its traditional form, based on the apparent evidences in the two sides of nature, namely the living (organic) nature and the physical nature. For the evidences of design and harmony in the physical nature, the

theists increasingly depend on the scientific discoveries about the wonders of the universe.

However, for the evidences of design in the world of living things we do not have to depend entirely on the biologists and the zoologists because ordinary people can directly observe natural phenomena and find the evidences of intelligence involved (design and purposiveness) almost everywhere. Needless to say the biological knowledge can be useful. Earlier we discussed the examples of apparent design in the human body, such as the eye, the ear, the teeth, the hand and fingers, the spine, the skull and the reproductive organs. The palm of the human hand too is interesting to observe. It is not difficult to figure out why the inner surface of the hand and the fingers are covered with soft flesh. It is needed for practical purposes in man's daily living. Even a simple structure like the human palm shows an evidence of design and purposiveness. Consider the useful purpose of the eye-brow and the hairs in the nostril. Nature's care reaches even to such small things. In our busy life, perhaps not very many individuals pay attention to such things. If we do and look around we shall find numerous cases of apparent design and purposiveness.

However, there are critics who maintain that the theistic argument from design was destroyed philosophically by Hume and Kant, and scientifically by Charles Darwin (1809-82), and that natural theology generally has been discredited by Hume and Kant. We have been trying to show that this is a gross exaggeration. The case of Hume and Kant was already discussed at some length. We discussed Darwinism briefly earlier.

There have been plenty of critics of natural theology. And the critics are not always atheists and philosophers. Some of them are Christian theologians, including Karl Barth, who is perhaps the most famous theologian in the 20th century. Barth's opposition to natural theology is based on his theology. He exclusively concentrates on God's revelation through Jesus Christ and refuses to consider rationally God's revelation. Hence there is no place for natural theology in Barth's theology. A theological position like Barth's is called Fideism. Fideism is a theological view which assumes that knowledge originates in a fundamental act of faith, independent of rational presuppositions. But it seems that there is some oddity here. Who has given man his reason? Reason is one of God's precious gifts

to man. If it is so, what is wrong with the use of God's gift in man's most important undertaking, namely, in the search for God. Of course, I am not saying that faith is unnecessary or unimportant in religion. It is not what I mean. This is a different question.

Here is a crucially important question: Does the Holy Scripture teach or advocate fideism? My answer is, it does not. I quote from both the New Testament and the Old Testament. "For He (God) has set a date when He will judge the world with justice by the man He has appointed. He has given proof of this to all men by raising him from the dead (Acts 17:31)". The apostle Paul says "He (God) has given proof of this by raising him from the dead". People did see the resurrected Jesus. So the apostle does not advocate fideism.

I quote another saying of the apostle. "Since the creation of the world God's invisible attributes, His eternal power and divine nature, have been clearly seen, being understood through what has been made, so that they are without excuse (Romans 1:20)". Now I quote Acts 14:3, "Paul and Barnabas spent considerable time there, speaking boldly for the Lord, who confirmed the message of His grace by enabling them to do miraculous signs and wonders". God performed miracles before the eyes of people to support the apostles' evangelism.

In order to show that God is not a fideistic Deity, I give Isaiah 41:13-14, 18-24. God does something before the eyes of people to prove that only He is the true God. Before closing our consideration of 'fideism', I quote the words of the apostle Peter. "Always be prepared to give an answer to everyone who asks you to give the reason for the hope that you have (1Peter 3:15)". Now we will return to the question of our main concern in this chapter, namely, Natural Theology.

Natural theology has not been dead after Hume and Kant. But it has undergone some development, and its forms and methods are not the same as before. New generations of natural theologians expressed their renewed convictions, refined their arguments and took advantage of the new knowledge about the natural world provided by modern science. Perhaps it would be an exaggeration to say that there has been a resurrection of natural theology.

Critics of natural theology have failed to notice, or have chosen to ignore the fact that Kant himself modified his negative assessment of natural theology even in his *Critique of Pure Reason* (1781) and

modified it further in his *Critique of Judgment* which was published 9 years later. I emphasize that all that theistic arguments undertake to prove is that a Mind lies at the basis of nature or behind nature, and not to prove the existence of God. I assume that Hume and Kant will have no reason to maintain their misgiving about natural theology. J. H. Bernard who translated into English Kant's *Kritik der Urteilskraft (Critique of Judgment)* expressed his view of Kant's position:

> Kant's position seems to come to this, that though he never doubts the existence of God, he has very grave doubts that He can be theoretically known by man. That He is, is certain; what He is, we cannot determine.[21]

For man as a finite creature, God is the ultimate mystery. Therefore man's reasoning and speculations, short of God's special revelation, about God's nature and ways are unreliable and uncertain. However, with respect to the existence of God the situation is quite different. We have reason to think that the existence of the universe and the astonishing phenomena thereof constitute part of God's self-revelation to the humans who have eyes to see and the mind to think and understand.

On the other hand, the existence of man who thinks, wonders, searches for the meaning of the universe and the human life, experiences his spiritual freedom, creates, and asks such question as "Why is there anything at all rather than nothing?", is no less astonishing a fact than the existence of the universe.

Before I bring my discussion of natural theology to an end, I would like to point out that the Holy Scripture does not forbid natural theology, nor says that it is useless. Rather the Scripture acknowledges that natural theology is valid and can be useful. Here are the main Biblical passages that endorse my view.

<div align="center">

Acts 17:27, 14:17
Romans 1:18-20
Isaiah 41:20
Job 38-42:3

</div>

CHAPTER 6

The Cosmic Teleology of Fredrick Tennant

There have been many who observed the phenomena of the universe and found in them the evidences of God's existence. But Fredrick Tennant, a philosopher and theologian in the University of Cambridge, Great Britain, considered these evidences synthetically and formulated a systematic argument for Theism. Tennant called his argument a 'cosmic teleology' or 'a wider teleology'.

Tennant's teleological argument for Theism is presented in Volume II of his *Philosophical Theology* (1930). Tennant's presentation in this volume is regarded as the most powerful theistic argument among those written from the teleological point of view. Yet Tennant does not maintain that his cosmic teleology proves the existence of God because he is aware that God is not such a Being that can be proved by the intellect of finite human beings. Tennant is modest and says that his theistic argument is intended to show the probability of God's existence and the reasonableness of the belief in God. But one who reads Tennant's argument carefully will be impressed with the brilliance, power and cogency of the argument. As I cannot afford to present Tennant's complex arguments in details, I will submit only the main points and structure of his argument. I will express my own view here and there and introduce the valuable insights of other scholars, to make it an even more convincing argument for Theism.

Tennant gave six features of the universe which can be empirically

found and confirmed. The six features are: the knowability or intelligibility of the world (or the adaptation of human thought to things), the internal adaptedness of organic beings, the fitness of the inorganic to minister to life, the aesthetic value of Nature, the world's instrumentality in the realization of moral ends, and the progressiveness in the evolutionary process culminating in the emergence of man with his rational and moral status.

Tennant says that a brief examination of these features will enable us to estimate the respective strengths of these more or less independent arguments and also to appreciate the interconnections within the world, and the comprehensive teleology which such interconnectedness suggests.

The first feature; we begin with the mutual adaptation of human thought and things. The correspondence between the human thought and the external world, rendering science possible, has evoked the epistemological argument for the existence of God. In the universe there are different kinds of order. The most fundamental order is that the universe is not chaotic but orderly, and that the human mind can comprehend it. In other words, the universe is knowable and intelligible. It is because the universe has an orderly and rational structure, and the structure matches the human mind that man could develop natural science and invent machines like airplane and computer and other machines for utilization in life. We have already touched and explained this point when we dealt with 'the wonder of mathematics' in chapter 4 of this book. Mathematics and natural science (and technology) are not of the same category, yet the key point we wish to draw attention to is common in both cases. Hence we would not need to repeat the same explanation.

The relationship between the universe and the human mind is, in a way, comparable to the relationship between the lock and the key. This metaphor of lock and key was mentioned by us in chapter 4. Man locks or unlocks (to open) a lock with a key. He can do this because the lock and the key match. There is an adaptation between the lock and the key. As a key unlocks a lock, so the human mind can understand and fathom the universe. Man can do this because there is an adaptation between his mind and the universe (nature). Natural science which man has developed is an indication and evidence of this.

The proposition that natural science which was developed by humans has achieved a great success because there is an adaptation between the human mind and nature (and the real world), may sound like a fantastic notion. However, we actually assume it in our daily life. Let me explain the point by illustration. Suppose there are two apple trees here. I counted 70 apples on one of the two and 60 apples on the other tree. Then, how many apples are there altogether? I can figure out that there are 130 apples by a simple arithmetic 70 + 60 = 130. But if someone did not know or did not believe arithmetic, he will count the apples on the two trees and get 130. In both cases the correct answer is 130 apples. In the first case we get the answer 130 by simple arithmetic 70 + 60 = 130 without actually counting all the apples on the two trees. What is the ground of this procedure? The ground is our belief that the mathematics which the human mind has worked out (invented) by his logical reasoning matches nature and the real world. In our daily life we take it for granted and confirm the truth of this belief by our common experiences. When we conduct our daily life on the assumption that this belief is truth, we see the expected results. How have the humans come to have this belief? Part of the answer would be that the belief is the result of repeated common human experiences. Also probably the belief came from the intuition of humans.

Although we take the truth of this belief for granted in our life, probably a vast majority of people would not have thought about this question. The fact that we got the correct answer 130 apples by arithmetic and also by actual counting, means not only that arithmetic and mathematics are very useful in life, but also that there is a correspondence between the human mind and the real world. To express another way, there is the actual congruity of the mind with the world it apprehends. Scientists conduct their scientific research and operation according to this belief. The marvelous success of natural science was achieved because this belief is a true belief, namely, truth.

The proposition that there is an adaptation of the human mind to the world is applicable not merely to the scientists' scientific research of the world. It is also applicable to man's appreciation of the beauty of nature. Man values the beauty of nature because he feels pleasure in his eyes and mind when he sees beauty. In this case there is an

adaptation of man's aesthetic sense to the beauty of nature. There is a match between the two just as the lock and the key match.

This is true of man's knowledge of the world as well. I have already referred earlier to the wonder of man's mental activity such as knowing. Perhaps not very many people realize how complex the mental process is when man knows something. I have quoted earlier the philosopher Karl Popper's saying: "The phenomenon of human knowledge is no doubt the greatest miracle in our universe. It constitutes a problem that will not soon be solved".[1] Another distinguished philosopher William Temple writes: "We are so impressed by the greatness of the world we know, that we seldom reflect upon the amazing fact of our knowing it. Some men have even been so overwhelmed by the greatness of the known world as to deny all significance to the knowing mind. But this fact of knowledge is more remarkable than all the varieties of known objects put together. For the mind which knows is in a perfectly real sense equal to what it knows, and in another real sense transcends it unless what it knows is another mind which also knows. The mind of the astronomer is equal to so much of the stellar system as he grasps, and transcends it in so far as he knows it while it does not know him. That there should 'emerge' in the cosmic process a capacity to apprehend, even in a measure to comprehend, that process is the most remarkable characteristic of the process itself".[2]

This adaptation of the human mind to the world is the first of the six features of the universe which Tennant deals with in his theistic argument (called "Cosmic Teleology" by him). Tennant found the evidence of God's existence in these features which are, according to him, empirically found and verifiable.

I have explained above the adaptation of the human mind to the world with four examples: namely, mathematics, natural science, the appreciation of the beauty of nature and man's mental activity of knowing something. If the real world were chaotic and disordered, natural science, the appreciation of nature's beauty and (intellectual) knowing would be impossible. However, what is required in the three cases is not the same kind of rationality. There is some common element in them, but each of the three has a peculiar characteristic of its own as well. What is required for natural science is the mathematical rationality and the laws of nature. What is required

in the appreciation of nature's beauty and in (intellectual) knowing is not a mathematical, logical mind.

Mathematics is a science of number by logical reasoning. But there are other kinds of logic in addition to mathematical logic. An example of such logic, other than the logic of mathematics, is what might be called "the logic of the heart". It is the logic (or principle) which is put to use in the human relationship such as friendship, love, trust, graciousness, respect, and so forth. Another example is the logic in arts (such as fine arts, sculpture and music) concerned primarily with the creation and appreciation of beauty.

The universe is astonishing indeed. No matter how astonishing this universe may be and how incomprehensible its origin may be, we attribute to it the rational nature in some aspect of it, congruous with the human mind. Natural sciences such as physics, chemistry, and astronomy proved that nature (the universe) follows mathematical laws in its every move. Man grasps the universe with some understanding because the human mind, like the universe, has a rational nature due to his reason, and the two match.

Then, how has this astonishing universe come to exist? An explanation is needed for the existence of this universe and for the fact that the universe is not chaotic, but is ordered and of rational nature in some aspect of it. We hesitate to say that the universe is rational in all aspects of it because the beauty of nature is not of rational nature in the ordinary sense of the word, and also because we sense that there is a mysterious dimension in the universe. We recall that in Part One of this book in which we dealt with the four distinctive facts (or features) of the universe, we faced the same question and needed to find an explanation for this. The four distinctive facts of the universe are the wonder of mathematic, the anthropic principle, the biological evolution and the emergence of the human mind, and the existence of the value of truth, goodness and beauty. We also recall that these four features of the universe can be explained by Theism, namely, a living personal God exists and He created the universe and man for a purpose. The universe and the human mind match because the same God created both somewhat like the case the lock and the key match because one craftsman made the two for a purpose. It is our contention that only Theism can provide an adequate explanation for the existence of this astonishing universe

and for the fact that there is an adaptation of the universe and the human mind.

In this universe (nature) the human beings with an intelligent mind and a moral, spiritual character have emerged; and the values of truth, goodness and beauty have appeared. In addition, nature performs a moral education for humans. I will deal with this remarkable subject in some detail later. Further, in the evolution of the universe and in the process of biological evolution there is an intimation of direction and purpose. This implies that the universe exists for a spiritual purpose. However, since the universe is a mindless material entity, unable to think or love, or know anything, we cannot imagine that the universe provides, on its own initiation, the natural environment for the benefits of humans, performs the moral spiritual education of humans, and works to realize its own purpose. Only an intelligent personal being is capable of working to realize its purpose. The values of truth, goodness and beauty also (which have appeared in the world) lead us to think that the power that is responsible for this must be a personal Being since only a person can esteem and appreciate such spiritual values. Such being the case, we reason that there is an independent personal Mind behind the universe and He is active in these ways to realize His purpose. This personal Mind is called God by the theists.

It has been our proposition that the universe and the real world have a rational structure and this rational structure matches the human reason. The success of natural science shows the validity of this proposition. This proposition constitutes the prerequisite for man to be able to think rationally and make sensible judgment about men and things in the world.

Reality (not the ultimate reality) is not a monolithic whole, composed of one undifferentiated component. To speak from our empirical point of view, the structure of reality consists of a scale of being, namely, matter, life, mind and spirit. I elaborate on this. There are inorganic matter, organic matter, vegetable life, animal life, man as an intellectual being and man as a spiritual being. To speak from another empirical point of view, in this universe, human beings with an intelligent mind and a moral spiritual character have emerged; and the values of truth, goodness and beauty have appeared. Further, in the evolution of the universe

and in the process of biological evolution there is an intimation of direction and purpose.

To speak from another empirical point of view, there are various kinds of logic and rationality. Mathematical logic is only one of them. Besides, there is what might be called the logic of the heart. This logic of the heart is valid and at work in the personal relationship of persons. In the social and collective life, the logic in terms of law, justice and power is at work. In the religious life another kind of logic is at work such as faith, piety, devotion, penitence on the one hand and on the other hand grace, love, forgiveness and salvation (of God)

In view of these observable empirical facts we would say that reality is multi-dimensional. The highest dimension is spirit or personality which is found only in the human and the Divine person. Personality is marked by self-consciousness, freedom, responsibility, ability of self-determination, character and purpose. According to the Bible, man was created in the image and after the likeness of God (Genesis 1: 26-27). Personal being's life is purpose-oriented. Personal being has the capacity of choosing among different ideals, among different philosophies of life and among different values. Personal being has also capacity of choosing among different types of life. Human being has some extent of power of choosing between the authentic and the inauthentic selfhood. But it would be an exaggeration to say, as some existentialist philosophers do, that a human being can make his own self. Human being does not have a complete freedom. Man's freedom is limited and hampered by various factors such as heredity, emotion, environment and sinful human nature.

The human life has brought to light the astonishing potentialities latent in man and in the physical universe. By "the astonishing potentialities in man" I do not merely refer to the powers of human reason or to the amazing achievement of the human mind, namely, natural science and mathematics. The human being is a microcosm in which the macro cosmos reveals itself. The human being is not just a microcosm which reflects or sums up in himself the macrocosm. He is much more than that. Man as a free spirit transcends nature. Freedom of the human spirit is not a natural phenomenon, but is something which belongs to an entirely different order. Because of

this freedom man is a truly unique being in the universe. Because of this free spirit the humans have an unlimited capacity of history-making and achievement; and the range and direction of the human history are unforeseeable.

"The astonishing potentialities in the physical universe" are revealed in such facts as, first, provision for the emergence of free spiritual beings (human beings). Secondly, the appearance of the values of the true, the good and the beautiful: which are in correspondence with the intellect, the will and the emotion of the human mind. Truth, goodness and beauty are part of the nature of reality and at the same time the three are innate ideas imprinted in the heart of man. Truth, goodness and beauty existed before the emergence of man and originated from God. The true, the good, and the beautiful are part of the human soul's spiritual environment and serve an educational purpose for human beings. Truth is the principle of thought and goodness is the standard of deeds.

The astonishing potentiality of the physical universe is revealed, thirdly, in that which is referred to in the concept of 'anthropic principle' which we have already dealt with in Part One. The astonishing potentiality of the physical universe is revealed, fourthly, in the exquisite beauty and grandeur of nature and in the remarkable order of the universe as discovered by natural science.

The features of man as an intellectual and spiritual being are in correspondence to the amazing features of the universe. Arthur Schawlow, a scientist, said: "It seems to me that when confronted with the marvels of life and the universe, one must ask why? and not just how? The only possible answers are religious.... I find a need for God in the universe and in my own life". Schawlow received Nobel Prize for physics in 1981. He was professor of physics at the University of Toronto and at Stanford University. Another scientist Vera Kistiakowsky said: "The exquisite order displayed by our scientific understanding of the physical world calls for the divine". Kistiakowsky was professor of physics at Massachusetts Institute of Technology as of 1992.

The second of the six features of the universe which Frederick Tennant deals with in his 'cosmic teleology' is the internal adaptedness of organic beings. Until the emergence of Charles Darwin's theory of biological evolution in the 19th century, the internal adaptedness of

the living things for successful survival was regarded as due to the fact that their organs were designed by the divine Creator for that purpose and that the apparent design of the organs is an evidence of God's existence. But Darwin asserted, as we saw, that the adaptedness of living things for survival can be fully explained by what he called "natural selection", in other words, by "the preservation of favoured species in the struggle for life" and that therefore the idea of the design by the Creator is unnecessary. If it is so, then the traditional design argument for the existence of God also is to be disputed.

In the preceding chapters we have engaged Darwinism, debated with Darwinians and other atheists and refuted their theories. Then, have we succeeded in our effort to refute them? I believe that we have.

However, F. R. Tennant does not, in his cosmic teleology, debate with the Darwinians about the controversial question of the seeming design of the organs of living things. He tried to solve the issue in the cosmic level where the Darwinian biology is inapplicable; accordingly the debate with the Darwinians is unnecessary. Darwinism is applicable only in the area of living organism. Tennant writes: "The discovery of organic evolution has caused the teleologist (the theist) to shift his ground from special design in the products to directivity in the process, and plan in the primary collocations". Tennant challenges the Darwinians to answer this question: Then from where have come the directivity in the evolutionary process itself and the mechanism of natural selection by which the evolution of living things allegedly is achieved? The Darwinians are not able to answer these questions. Thus, Tennant shifted the substance of the debate from the organ of living things to the evolutionary process which has a cosmic dimension. The evolutionary process has a cosmic dimension and the evolutionary process is not merely a biological phenomenon; the laws of nature and nature's constituent elements also are involved in it. By his cosmic teleology Tennant means to say that the evolutionary process itself was designed by God for His specific purpose. Since the subject matter of the debate is shifted from the biological to the cosmic level, Tennant's cosmic teleological theory is outside and beyond the range of Darwinism; hence the debate with the Darwinians is needless.

The third of the six features of the universe which Tennant deals

with in his cosmic teleology is the fitness of the inorganic to minister to life. We have noted earlier that the plants and the animals are adapted to the natural environment for survival. On the other hand, it was discovered that the physical environment of nature also is adapted to the living things to enable their survival. This has been confirmed through the discoveries made by natural sciences like physics, chemistry and astronomy. To give one example which is simple and easy to understand, the planet earth is maintaining mild temperature to enable the living things to survive and flourish; in other words its temperature is not too hot or cold, but suitable. To realize this the distance between the sun and the earth and the speed of the rotations of the earth must be suited to this. There are, it was discovered, many adjustments and preparations made in the physical conditions of the universe to enable the emergence and survival of living things. The specific elements of these adjustments are not only complex, but also delicate and prudent. So much so that it is indiscreet to say that they are simply the outcome of accidents and coincidences.

Probably the most prominent scientist that made a pioneering contribution in this question and drew attention to this feature of nature is Lawrence Henderson (1872-1942), professor of chemistry at Harvard University. He published a historic book in 1913 with the title *The Fitness of the Environment*. Yet in the opening pages of the book Henderson emphasizes that he is not the first discoverer of this and that there were natural theologians who discovered this and presented its concrete evidences in their writings with the tile *The Bridgewater Treatises*. This book contains eight treatises written by eight natural theologians and were published between 1833 and 1836. The intention of these theologians was not to write scientific treatises, but to explain various aspects of 'the power, wisdom, and goodness of God as manifested in the Creation'. Henderson writes: "An examination of Whewell's *Bridgewater Treaties* at once reveals important discussions of environmental fitness". Henderson selected 19 examples of environmental fitness discussed in that book and says: "It is hard to understand how such idea could have fallen into oblivion".[3]

I hesitate to introduce here the content of Henderson's historic book because they are mostly scientific discussions using technical

terms. Four years after the publication of *The Fitness of the Environment* Henderson published another book with the title *The Order of Nature (1917)*. Fortunately, in the introduction to his new book Henderson presented the summary of the content of *The Fitness of the Environment* in non-technical language. I quote here part of it: "Many of the characteristic of inorganic nature, like the stability of the solar system and the enduring movements of the waters of the earth, are the very condition of existence for life as we know it and the source of diversity in organic evolution....Whatever may be the final judgment of natural science upon either organic or inorganic harmonies, biological fitness is manifestly a mutual relationship. For the organism and the environment each fits and is fitted by the other. In a recent book I have tried to recall attention to the many interesting peculiarities of the environment and to state the facts concerning the fitness of the inorganic world for life. This has turned out to be more notable and extensive than biologists had supposed. Firstly, the very nature of the cosmic process and of the physical and chemical phenomena of matter and energy bring about not only stability of the solar system, but very great stability of land and sea. Thus the temperature of the earth is more equable than it could be if the composition of the surface of the earth were other than it is. Thus the alkalinity of the ocean possesses a constancy which is nearly perfect, and this depends upon certain unique properties of carbonic acid. Thus the currents of the atmosphere and of the ocean, the fall of rain and the flow of streams are almost ideally regular, and are so only because water is different from any other substance. Secondly, the properties of water cause a mobilization all over the earth of most of the chemical elements in very large quantities, and no other substance could so effectively accomplish this result. Once mobilized, these elements penetrate everywhere, borne by water, and the penetrating qualities of water are unique. In this manner the whole earth has become habitable. Thirdly, even more significant appear what the chemist calls the properties of the three elements, hydrogen, oxygen, and carbon, from which water and carbonic acid are formed. These are the most active all elements.... ...Nothing could replace them in such respect, for their utility depends upon a *coincidence* of many peculiar and unequaled properties which they alone possess. It is therefore certain that in physical and chemical

characteristic the actual environment is the fittest possible abode of life as we know it".[4]

The foregoing accounts are a testimony of a distinguished chemist about his findings on the fitness of the environment for life.

Thus nature is adjusted to man and other living organisms for their survival. Without these adjustments man would not have even emerged on the earth. If we consider the size of the earth, its place in space and the nicety of the adjustments, the chance of some of these adjustments occurring accidentally is in the order of one to many million and the chance of all of them occurring cannot be calculated even in the billions. These facts cannot, therefore, be reconciled with any of the laws of chance. It is impossible, then, to escape the conclusion that the adjustments of nature to man are far more amazing than the adjustments of man to nature. A review of the wonders of nature demonstrated beyond question that there are designs and purpose in it all. A program is being carried out in all its infinite details by the Supreme Being that we call God.

Certainly chance has little place in the formation of our earth which is suitable for the habitation of the human beings; and in the formation of this astonishing universe which is governed by laws. I explain my point by an illustration. Suppose you have ten tiny balls. Nine of them are white and one is red. Put them in your pocket and give them a good shake. Now try to draw out the red ball. Your chance of drawing the red ball is 1 in 10. Your chance of drawing the red ball in succession is 1 in 100. Your chance of drawing the red ball 3 times in succession would be one in a thousand. Your chance of drawing the red ball 4 times in succession would be one in ten thousand. Your chance of drawing the red ball 100 times in succession would be the unbelievable figure of one chance in many billions. And so on.

The purpose of my illustration above is to show how enormously figures multiply against chance. So many essential conditions are necessary for life to emerge and exist on our earth that it is mathematically impossible that life could emerge and survive by chance. Therefore some intelligent mind must have been involved. And it is a Divine Mind, in other word, God.

The fourth of the six features of the universe dealt with in Tennant's cosmic teleology is "the aesthetic value of nature". This is Tennant's

aesthetic argument for Theism based on the beauty and sublimity of nature. Tenant says that this argument may fall short of cogency, but it forms a link in the chain of evidence (of the existence of God) which his comprehensive teleology presents. We will not introduce here Tennant's aesthetic argument since we are going to discuss the subject of beauty and sublimity of nature separately and we want to avoid repetition.

The fifth feature of the universe dealt with in Tennant's cosmic teleology is "The world's instrumentality in the realization of moral ends". This extremely significant fact was pointed out and explained by many scholars. Tennant writes: "The whole process of Nature is capable of being regarded as instrumental to the development of intelligent and moral creatures. Acquisition of moral status is in line with the other stages of the long 'ascent of man', and is its climax". I will not present here Tennant's exposition of this theme since it is lengthy and we need to save space. The fact that Nature is instrumental in the realization of moral ends has a few important implications. First, it is another indication that the ultimate reality behind the universe is a personal being and is of moral and spiritual character. Secondly, the universe has a moral and spiritual purpose. Thirdly, man holds the central and highest status in the universe because man alone is a moral spiritual being. Man is not only the crown of nature's long upward progress, but also its end or goal. Of course, man's morality is imperfect and flawed; and he often fails and is a sinner. But only man can do evil and become a sinner. Animals and all other living things cannot do evil and become a sinner. This fact reveals that man holds the unique status in nature. Fourthly, as a moral and spiritual being man can have a relationship with the God, who is a personal Deity of moral nature.

Along with having brought about the emergence of man, nature provided two essential things. The first is the raw materials which are necessary for man's survival, such as water, air, food, trees and so on. Trees are used for building houses and bridges and for other purposes. Nature also prepared various conditions necessary to cultivate and develop man's intelligence and morality, in other words, for man's education. What nature has prepared for man's education is shrewd and far-sighted, and is comparable with what the humans prepare for the education of their children, such as building schools, training teachers, providing text-books and the like.

We have discussed, the reader will remember, what the cosmologists call "the anthropic principle" in chapter 5. The word 'anthropic' comes from Greek word 'anthropos' meaning man. So here 'anthropic' would mean human-centred. Cosmologists (e.g. Brandon Carter and Robert Dicke) who coined the term "the anthropic principle", designed to draw attention to the fact that the universe is amazingly adapted to man and other living things for their emergence and survival. This adaptation of the universe to man is in addition to the fitness of the environment on the earth and the solar system.

Sir Denys Wilkinson, a professor of physics at Oxford University whom I had introduced in chapter 4 explained the anthropic principle and said: "The universe has to be as it is in order for life to have emerged, which depends on a large number of extraordinary coincidences". He gave a list of 23 coincidence, and made this remark which prompts a deep thinking: "What should we make of this remarkable catalog of coincidence that measures, in so many independent ways, the tight but necessary fit between us and our Universe? I should emphasize that the fit is indeed between us and the spatial whole of our Universe and not just now but always. That is to say that it cannot be argued that we simple occupy a niche in space and time within the Universe in which conditions have been propitious for our emergence. This is true in the trivial sense that we live on a suitable planet that happens to be suitably near to a suitable star, the sun. But it is not true in the sense that we might also be thought to happen to live in a part of the Universe, and at a particular time, where and when the laws of Nature and their constants have taken the right values to bring about all the necessary coincidences. Many of the coincidences refer to the Universe in the gross, not just to our particular bit of it; and our ability to give a rational account of the whole of the visible Universe within a single set of physical laws and their associated constants shows that those laws and constants cannot change significantly from place to place and from time to time within it."[5] Wilkinson continues: "We have to accept that our Universe, as a whole, is just right for us in a large number of independent and tightly constrained ways. I have already mentioned the obvious teleological explanation of final cause, that is to say, that in the beginning of the Universe God made the laws

and the constants as they are so that we might be here....For me, the natural world is so wonderful that I can only echo Walt Whitman: I know of nothing else but miracles."[6]

The sixth and last feature of the universe in Tennant's cosmic teleology is the progressiveness in the evolutionary process culminating in the emergence of man with his rational and moral status. We will not deal with this feature here because we fear that it will be rather repetitious since we have already referred to its main points briefly and piecemeal as opportunities arose.

Tennant thinks that each of the six features of the universe, if estimated one by one separately, may not be convincing as the evidence of God's existence; but when all six are considered and evaluated together the Existence of God would be indisputable.

With this, I bring to an end my presentation of F. F. Tennant's cosmic teleology in an abridged form. Tennant's cosmic teleology is included in the second volume of his *Philosophical Theology* (1929) which has been evaluated as a great work. His cosmic teleology is, in essence, an argument for Theism, hence it is natural theology.

CHAPTER 7

The Beauty and Sublimity of Nature

With the industrialization of society more and more people left the rural area and have moved to cities. People who live in a city have fewer contacts with nature; accordingly they would have fewer opportunities to be enthralled by the beauty and sublimity of nature. To a sensitive person nature appears to be saturated with beauty. Beauty of nature manifests itself even in the most insignificant plants. Have you noticed the enchanting beauty of the fall colors? What a variety of beauty nature has! Some beauty of nature cannot be properly characterized by the word beauty. The words sublimity, majesty or grandeur would better characterize them. The sublime has something in common with the holy which is an attribute of God.

This writer's intention in this chapter is not merely to describe and extol the beauty and sublimity of nature, but to express his view that the beauty and sublimity of nature can provide an opportunity for man to have a religious experience, and also to present the view that there are many different levels of reality, nature being a prominent part of it. God is the transcendent Being, yet is capable of being present in all levels of reality. Nature too has different aspects, for example, nature as seen by scientists, nature as seen by businessmen, nature as seen by artists and poets, nature as seen by deeply religious persons and so on. Thus, nature has various aspects and characteristics. All see the same nature, but they see it from

different angle, arising from different interest, different perspective and with different question.

One glance at the wonders of nature and the majesty of the universe may lead a simple ordinary person to have a religious sentiment and to sense the reality of God.

Here we focus on the beauty and sublimity of nature which appeal to our aesthetic sense and also can arouse a religious emotion. Nature is saturated with beauty and beauty is inherent in nature. As I have discussed the beauty of nature in chapter 2, in this chapter I would like to focus on the sublimity of nature.

Before the sublimity of majestic scenes of nature, man feels awe and become pious. He may feel that he stands in the presence of the divine sacred Being who transcends this mundane world. In this case, man's experience of the sublime in nature combines with his religious experience. Also in this case, Nature, despite its material makeup, points beyond itself to the transcendent Being and intimates that there is such a Being. Considering this point, I think that nature does a religious education for humans.

I have remarked above that the sublime has something in common with the holy which is an attribute of God. In the presence of that which is sublime, the self will feel itself to be so small and insignificant. The self stands in awe. This pious frame of mind is akin to worship. Before the sublime phenomenon (such as the ineffable majestic scenes of nature) man intuits the existence of God. This is a frame of mind which is quite different from the intellectual posture of mind in which man makes efforts to ascertain the existence of God by rational thought and inference.

The title of this chapter is "The Beauty and Sublimity of Nature". But I have to emphasize that there is a clear distinction between beauty and sublimity. Looking at the beautiful scenes of nature our minds are in a pleasant and restful mood; but, when looking at the sublime phenomena of nature the mind is stimulated because nature presents awesome and even 'frightening' aspects. According to Kant, in the apprehension of beauty "the mind is in restful contemplation" whereas "the feeling of the sublime is a feeling of pain and at the same time a pleasure excited".[1]

In art, poetry and religion, emotion plays an important part. In religion both emotion and intellect participate and play distinctive

roles. Some people think that for the comprehension of truth only intellect is to take part and emotion must be excluded. I think that this is not a correct view.

There are many different levels and dimensions of reality; and each of the different levels of reality demands a different approach and different language. The subject matter determines the kind of approach which is appropriate to it and the appropriate method of knowing its truth. Not everything in reality can be grasped by, say, the scientific method. For instance, the internal human experience such as love, sorrow, guilty feeling and moral struggle cannot be understood by scientific method. This is true of the religious experience as well.

Similarly, not everything in reality can be grasped by mere intellect. The human heart and emotion will provide a better approach to art, music, poetry and religion although there is room for intellect as well to play a part in them. I quote a very significant remark made by the physicist Steven Weinberg who is a Nobel Prize winning physicist (1979). He acknowledges that the aesthetic sense of physicists and mathematicians plays a part in the discovery of scientific and mathematical truths.

> It is precisely in the application of pure mathematics to physics that the effectiveness of aesthetic judgment (in which emotion is involved) is most amazing. It has become a common place that mathematicians are driven in their work by the wish to construct formalisms that are conceptually beautiful. The English mathematician G. H. Hardy explained that mathematical patterns like those of the painters or the poets must be beautiful. The idea, like the colours or the words must fit together in a harmonious way. Beauty is the first test.[2]

In many fields of inquiry, "detachment" is highly recommended. But in the study of religion detachment is not recommended. It is all right to be detached and objective on some questions such as the nature of electron or of atom. But it is naive to think that a detached or indifferent person can study fruitfully about religious truth. There are truths that man can understand better through personal

involvement, such as truths about religion, morality and love. These truths are quite distinct from natural scientific truth. Every mature person will know this point through his personal experience.

How do you know that you have a free will? A person knows that he has a free will through his personal experience. This personal experience is the only proof for him. There is no other proof. The method of proof is determined by the nature of the case. How would you prove your own honesty, love and integrity? Only you can prove it for yourself. No one else can prove it. Even the atheist and the materialist will know this through personal experience. What I call "the personal world" is in sharp and fundamental contrast with the non-personal world such as the material aspect of nature.

Here we come back to the question of our main concern. I present a thesis that reality is multi-levelled and is hierarchical in a way. Implied in the thesis is that reality has a dimension of depth. A major shortsightedness of 'scientism' is that it does not see a dimension of depth in reality. It assumes that the universe is constituted of "matter", hence is subject to the exclusive scientific investigation. What is implied by "scientism' is an exaggerated and nearly idolatrous trust in the efficacy of the method of natural science applied to all areas of investigation. Scientism is also a kind of philosophy, a naive philosophy. Even a simple question can expose the fallacy of scientism and show the limited usefulness of natural science: Can we or not properly appreciate and enjoy the beauty of rose by the method of natural science? Another question: Can we tell the difference between good and evil, between right and wrong by the method of natural science? Science is not equipped with the concepts and categories which are adequate for dealing with beauty, moral experience, religious experience, human relationship, and other spiritual matters. Revealed in these experiences of the humans is that reality is of multi-level and multi-dimension. Both scientism and crude naturalism involve us in an one-sided abstraction. The two take a segment of reality – the segment to which measurement and quantitative analysis are applicable – and regard it as the most important part of reality.

Science is not something that exists independently of humans, but is an undertaking which is conducted by humans. There are three prerequisites for natural science to emerge and become workable: 1.

the existence of the universe (nature), 2. the laws of nature, and 3. human beings with intellect and freedom. Natural science cannot explain the origin of any of the three. Natural science is one of the many undertakings of humans.

Matter is the component of nature (the universe). In this nature composed of matter the phenomena of non-material quality appeared. Beauty and sublimity of nature are two examples. This fact is comparable with another fact that in the human face which is composed of matter there appear the phenomena of spiritual nature, such as love, compassion, goodness and friendliness or hate, anger, hostility, contempt and malice. These facts indicate that matter can become the bearer of the spiritual (This is called the sacramental principle in theology), and suggest that the ground of the world is spiritual.

Beside beauty and sublimity, nature also exudes an air of mystery. However, some individuals of today who live in a secularized society and are under the heavy influence of scientism, materialism and atheism do not sense any mystery in nature. It appears that they have lost the ability to sense mystery while living in the mysterious universe. Yet they may be able to sense a different kind of mystery, namely, the mystery of being. Man does not only wonder about our astonishing universe and ask how it came to exist, but he also asks a different kind of question: Why is there such thing as the universe? Why is there something rather than nothing? Why is there anything at all? Man is shocked by the fact that there is something rather than nothing, and that there are a large number of things. Man senses the Mystery of Being. That something exists at all is astonishing and arouses wonder, and man seeks to find an explanation. A philosopher said: "The contemplation of sheer nothingness as a possibility leads to the perception that any kind of existence requires an absolute Being".[3] To a man who is shocked by the fact that there is something rather than nothing, the existence of this astonishing universe is a mighty evidence of the Existence of God. Some individuals are not able to sense the mystery of Being, nor the mystery of the universe. In our view this inability is not something to boast about or to be happy about. It is a deficiency and a shortcoming. Further, the fact that there are such things as religion, morality (good and evil) and 'beauty and sublimity' is another kind of mystery.

Albert Einstein, a great scientist of the 20th century, said: "The most beautiful and most profound emotion we can experience is the sensation of the mystical. It is the sower of all true science. He to whom this emotion is a stranger, who can no longer wonder and stand rapt in awe, is as good as dead. To know that what is impenetrable to us really exists, manifesting itself as the highest wisdom and the most radiant beauty which our dull faculties can comprehend only in their most primitive forms – this knowledge, this feeling is at the centre of true religiousness".[4] And on another occasion he declared, "The cosmic religious experience is the strongest and noblest mainspring of scientific research".

I have stated above that nature is saturated with beauty and that beauty is intrinsic in nature. We observe that not only nature in a large scale is beautiful (such as the starry heaven, the blue sky and the white clouds, and the lofty mountain) nature is beautiful in a small scale as well. Consider, for example, the leaves of trees and the color and fragrance of flowers, the shapes of birds and butterflies, the new sprouts of plants that appear fresh out of the black soil.

Unlike the products of nature, man's productions (except the fine works of art) are aesthetically unattractive. For examples, machines produced by man for utility, and the factories where machines are manufactured. Compare the hammering noises and unsightly scene inside the factory with the way nature works silently and unnoticeably. Compare the disagreeable stinks of chemical works with nature's fragrant distillation. Nature is comparable with music which is a harmony of many melodies. Nature's beauty is universal.

But for what purpose and for whom is nature beautiful? If there were no human beings who can appreciate beauty, what is nature's beauty for? Do the beasts, birds, insects, fish and germs appreciate the beauty of nature? When we consider the fact that nature's beauty and man's aesthetic sense match and that man alone in the world, so it seems, can admire and enjoy nature's beauty, we are inclined to think that the beauty of nature is there for human beings.

Since beauty is one of the three major values (together with truth and goodness) it implies that nature's beauty is not merely for sensual pleasure of the human eyes, it has a spiritual significance as well. The fact that the three values of truth, goodness and beauty are in correspondence with the intellect, the will and the emotion of man

respectively suggests that the universe is there for a spiritual purpose. This fact, together with another fact that nature is instrumental for the moral and religious education of human beings, strongly suggest that the universe has a spiritual purpose, which, in turn, implies that there is a Mind behind the universe. This Mind is called God by the theists. We have already considered nature's instrumentality for the moral education of human beings.

Summary

The God who designed the organs of the human body for the practical purpose such as survival and prosperity, and designed the fitness of natural environment (and of the universe) for the living things, also designed the beautiful natural environment for the human beings. In other words, God designed not just for survival and prosperity, but also for pleasure and happiness of the human beings and for their moral and spiritual (religious) education.

These facts reveal that God is not merely a Mighty Creator of heaven and earth, but also a personal, loving, and moral Deity. These facts match with the Biblical testimony about the compassionate, gracious and saving God. (e.g. Exodus 34:6 and John 3:16) So we, forgiven sinners, are very grateful and love God with our heart.

PART TWO

Argument from Man's Experience

CHAPTER 8

The Moral Experience

The moral experience and the religious experience which we will discuss respectively in this and following chapter, are not tangible experience that are capable of being perceived by seeing, hearing or touching. Therefore our discussion may seem merely theoretical and abstract. Yet both the moral and the religious experience have a realistic nature of their own. The philosopher Immanuel Kant (1724-1804), for example, was convinced of the reality of the moral law. He said: "Two things fill the mind with ever new and increasing admiration and awe, the oftener and more steadily we reflect on them: the starry heavens above me and the moral law within me". For Kant the moral law was a real thing no less than the starry heavens. Kant also said: "The moral law demands of us a disinterested respect; only when this respect has become active and dominating, it allows us a view into the realm of the supersensuous, though only a glimpse".

This writer has met a middle-aged man who told me that he was born and grew up in an environment which had no contact with religion. He said: "In my boyhood and youth I had no interest in morality and religion. I thought that morality and religion are useless things and I did not want to have anything to do with them. But after I have grown up and had experiences of life, I began to have some interest in religion and morality. I began to see something which I did not see before. I came to have a new eyesight, so to speak. I might call it a spiritual eyesight. I see some individuals around me who do

not appear to have the spiritual eyesight that I have. With a growing realization that religion and morality are not merely imaginary things I came to feel that there is a spiritual world". What this middle-aged man calls 'a spiritual world' and 'the realm of the supersensuous' in Kant's saying would have something in common.

I accept as true a commonly held view that there is the law of nature at work in the physical universe (nature) whereas there is a quite different kind of law at work in the world of humans, namely, the moral law. That there is the law of nature at work in the physical universe is a fact proven by natural science. It is proven by our common experience as well. It is self-evident to every sensible person. What happens if you throw a piece of rock from a balcony of a high-rise building? It will fall on the ground. Try it a hundred times and you will see the same result a hundred times. This happens because the law of nature is at work in nature, namely, the law of gravity. Then, consider what will happen to a man if he jumps from the same balcony of the high-rise building. He will fall on the ground to his death. Why? It is because the same law of gravity is at work. This is a matter of certainty. So we learn that to respect the laws of nature is necessary for our safety and survival.

But it does not appear certain or self-evident that the moral law is at work in the world of humans and in history. It is because the consequence of not respecting the moral law is not immediate and obvious. We even see sometimes that an evil man prospers and a good man fails or is defeated. Therefore some people even doubt that the moral law is at work in the world or that there is really such thing as the moral law at all. So we see that some people are almost indifferent to morality.

We acknowledge that the reality of the moral law is not quite obvious to everybody. This is similar to some degree to the fact that the existence of God is not obvious to everybody. The two facts are related and analogous. Is it regrettable that the existence of God and the reality of the moral law are not obvious (in the way the reality of the natural law is obvious)? If the two are obvious and incontrovertible, then everybody will respect the moral law and worship God as everybody keeps the laws of nature for his own safety and survival. If this is the case, this morality and this religion will not be worthy of the name. Here let us consider the distinctive nature

of religion and morality. Religion and morality are of the spiritual nature and belong to a different kind of order than the law of nature which is at work in the physical universe. For the purity of religion and morality man must have room for free choice either to worship God and respect morality or not to. Only if man worships God and respects morality willingly by his free choice, will the religion and the morality be worthy of the name. Man can make a free choice only if he is free as a person. Thus man's free will is prerequisite for religion and morality. God created man as a free person. The image of God in which man is made includes man's being a free person. God created man in His image, namely, as a person since God is a Person Himself. Before God the Creator all creatures including the human beings are like dust and a vapor. Yet, man as a person shares with God the high unique status of a person. Since God is a personal Being, 'personality' (the quality of being a person) is sacred and is of the highest order. Personality in man, because of its affinity with the personality of God, has a status independent of his social rank, class, race, ability, appearance and wealth. This affinity is due to the fact that "man was created in the image and after the likeness of God" (Genesis 1:26)

Love which is always for and between persons is the supreme good and is the norm of morality. Of course man's love is imperfect and man's free will is impaired. Man's free will is severely limited, but it is not non-existent. There are some people who deny man's free will. We emphasize again that every mature person can directly experience his free will. Freedom is an experienced fact of mature human persons.

Let us consider the question why the Existence of God is not obvious to human beings. In Isaiah 45:15 in the Old Testament we read,

> Truly Thou art a God
> Who Hides Himself,
> O God of Israel!

God is hidden in the shroud of mystery. God's plans and actions are a mystery to man. In contrast to idols which are false gods, the true God is invisible. God's hiddenness or invisibility is to preserve

the freedom of the human beings. Therefore God maintains "the epistemic distance" from the humans. This distance is also to make a worthy human life possible. If God is visible or His existence is too obvious, man's disbelief in God will be impossible. God will be an object of sight, rather than of faith.

God's "epistemic distance" is structured into the created order of the world for the purpose of preserving the human freedom. If God's existence is obvious beyond any doubt, then man "sees" Him. Then, who can maintain the composure of his mind before the almighty God who can, so to speak, throw him into the hell fire in the twinkling of an eye? And who would not prostrate before the almighty God with fear and trembling, worship and obey Him? Then, man is not a free autonomous being. For man to be able to love God and serve Him willingly there must be a measure of autonomy. Forced love or love out of fear is not love. Because of its very nature love cannot be forced. God would not desire love, worship or service which are forced in any way. It is for this reason that God remains invisible and maintains "epistemic distance" from the humans. There must be an element of uncertainty about God's existence which enables man to have an excuse not to believe in God if he does not want to. God honors man's freedom and his autonomous decision. Man is unique in the universe in that he is a free autonomous creature. All other creatures such as beasts and birds are not free autonomous beings. This fact is directly linked to another fact that there are no religion and morality in the world of sub-human creatures.

It is a mystery that there is the law of nature which is at work in the material universe whereas there is a quite different kind of law which is at work in the world of the human beings, namely, the moral law which is the principle of right and wrong. No human being, not even the atheist, the naturalist and the despiser of morality, are completely free from this moral law because morality is part of the human nature. What is meant by this statement is not merely that man cannot completely ignore morality, but also that man cannot completely get rid of thinking and speaking in terms of right and wrong, good and bad. Hence it is held that morality is part of the human nature. The human beings, regardless of being a believer in God and morality or not, feel indignation when they see ruthless

brutal treatment of people, unfairness, acts of betrayal, ingratitude, excessive egotism, cold-blooded murder and other inhumane acts.

The moral order is at work in the world independent of man's desire or not, regardless of man's acknowledgement of it or not. This moral order is a reality which is not subject to the changing moods or opinions of individual humans. Only Theism which affirms the Existence of a personal and moral God who created the universe and man does provide an adequate explanation for this fact.

I acknowledged above that the reality of the moral law is not quite obvious and indisputable. However, the experiential fact which is commonly observable in the human world that injustice, exploitation, faction, brutality and indifference to others bring on conflict and war whereas love, justice and care for others bring on peace and well-being is an evidence that there is a moral law at work in the world and that love and justice are norm of morality. There is another experiential evidence of the moral order in the world. It is our actual experiences which led to coin the proverb, "As a man sows, so he shall reap".

On the other hand there are atheists and others who give the naturalistic explanation of morality in opposition to the theistic explanation. By 'the naturalistic explanation' we mean the sociological and psychological explanation of morality and conscience. In other word, naturalists regard morality and conscience as the products of culture. This viewpoint results in moral relativism.

Clearly the naturalistic explanation of morality is connected with the naturalistic understanding of man. The two are in parallel. Naturalists regard man as a part of nature. This position is held by atheists such as materialists.

I have so far emphasized, however, that man is not merely a part of nature and that because of his free spirit (mind) man transcends nature in some way. This view of man is not merely a theory, but a fact which mature individual persons personally experience. This fact can, in my view, be confirmed by careful observation and analysis of human experience. Hence we maintain that the naturalistic understanding of man is only partly true and partly false.

Let us consider the question of conscience. It is indisputable that man's conscience is influenced by social and cultural condition and ingredients. But it is not true that man's conscience is wholly subject

to social and cultural influence. There have been individuals who had a sensitive discerning conscience, and did not go with the general trend of the times on social moral issues such as the institution of slavery, racism, sexism, human rights, war and nationalistic foreign policies of the government which are incompatible with the human brotherhood and the world peace. And they suffered hardships like hatred, alienation and persecution because of their peculiar uncommon attitude.

The conscience of an individual person may err in the judgment regarding what is right and what is wrong in particular cases, yet it does not fail to tell him that there are right and wrong things to do and that he should always choose what is right.

People's judgment regarding what is right and what is wrong, for examples, on divorce and capital punishment, may be influenced by historical and cultural factors; and in that sense the concept of moral relativism may seem justified. But the dignity of morality itself is not impaired thereby. Moral relativists are wrong when they fail to make a distinction between morality itself and the question on what is right and what is wrong. Man's judgment as to what is wrong may change according to the times, yet the absolute authority of the moral imperative is grounded on God who is of the moral nature. Morality is an expression of the nature and the will of God. Thus morality is inseparably tied to religion.

We emphasize, however, that God is not a divine despot; in morality the will of God is not some strange extraneous command imposed on man. "The will of God" is not an unfamiliar strange law that demands our obedience, but is congruous with the essential nature of man with its potentialities. To express differently, the will of God is harmonious with the inner voice of our own nature as man since man was created in the image of God (according to the Scripture). I illustrate, God commanded: "Love your neighbors". This is not a peculiar command; love is congenial to the human nature, and love is the supreme law of human life. The moral demand to love is intrinsic in our essential human nature. When man loves, his true humanity is realized. The command to love is always absolute, but its specific practice is related to concrete situations.

There are some psychologists and sociologists who deny the absolute character of the moral imperative with their psychological

and sociological explanations of morality. Psychologists argue that the strong demands of parents and teachers and the religious doctrine of the commanding God who punishes the disobedient by sending them to hell, arouse in the minds of children and others the feeling of something which is unconditionally binding and obliging, from which there is no way to escape.

Sociologists argue that the conscience of the masses was shaped through centuries of pressure exercised by the ruling groups, who did not hesitate to employ all means, including the most cruel tools of suppression – military, legal, educational and psychological. Such pressure during many generations produced an increasing internalization of the command, namely, the feeling of standing under the unconditional command, the absolute moral imperative.

Paul Tillich who is a renowned philosophical theologian made his refutation of psychological and sociological arguments about the origin of the conscience and morality. He said: "This type of argument seems convincing. But it is circular because it presupposes what it tries to prove – the identity of two qualitatively different structures, namely, the structure of causation and the structure of meaning (intentionality). In one case, persons and groups are bound by traditions, conventions, and authorities, subjection to which is demanded by the conscience. But within this structure of causation, another is manifest, what we call the structure of meaning or the structure of intentionality. This structure would be evident when a mathematician, psychologically and sociologically conditioned like everyone else, discovers a new mathematical proposition".[1]

I explain the point of Tillich's argument with simple language and by illustration. When a mathematician discovers a new mathematical proposition or when a scientist makes a new scientific discovery, the truth and value of their new discoveries are not affected by the sociological and psychological conditions in which they worked and made the discoveries. The truth of their new discoveries and the sociological, psychological conditions in which they lived, worked and made the discoveries, are two different things that should not be mixed up or confused. For this reason, the attempts to deny the unconditional character of the moral imperative by sociological and psychological arguments fail. In my view Tillich succeeded in his refutation of these arguments that have been presented by moral relativists.

CHAPTER 9

The Religious Experience

The title "the religious experience" covers a broad and wide area. Beginning with the questions, what is the religious experience? and what is religion? the title covers questions such as 'Does the religious experience have any reliable objective contents?' or 'Can we obtain some true knowledge about God from our religious experience?' However, the atheists and those who hold the worldview called 'scientism' laugh at the term 'religious experience' and dismiss it. We do not take the worldview called 'scientism' or atheism seriously and reject them.

It is because we are convinced of the existence of God through our thorough and extensive consideration in the preceding chapters of this book and through other ways, and we hold that it is quite natural that there are individuals who believe in a religion of one kind or another and who say that they have had some religious experience. And the religious experience will strengthen the belief in God of those who already believe in God.

William Temple (1881-1944) who is a highly respected and influential philosopher of religion, expressed his view that the world view of the theists who have an understanding of religion is superior to that of the atheists who lack the understanding of religion because the atheists do not see what the theists see whereas the theists see what the atheists see and see also what the atheists do not see. In addition to this view we might say that a person who had some

religious experience sees more than a person who had no religious experience, and his range of view is broader than that of a person who had no such experience.

We are aware that there are people in the world who have no interest in religion. Since the secularization of society is deepening, the number of such people will probably increase in the future.

The Christian theologian John Macquarrie of England made this comment regarding people who have no interest in religion.

> There are some people who seem to be without conscience and are amoral, but that does not invalidate the claims of morality, and we would regard such people as abnormal. Similarly there are people with no ear for music or no eye for painting, but that does not place the arts in question or make the criteria of good music and good painting something altogether subjective. Perhaps one could say something similar in the case of religion, and this might find some support in the fact that the non-religious seem to need some substitute for religion.[1]

What dose Macquarrie mean by saying that people who have no interest in religion need some substitute for religion? For instance, some people who are not interested in religion have almost religious passion for arts or sports. For another instance, in the former communist countries where atheism was strongly upheld, people almost deified their dictator. For the third instance, in some countries people are devoted to the state or the monarch. Their patriotism for the state is almost comparable with religious zeal. For the fourth instance, there were people who manifested almost religious enthusiasm for the defense and propagation of a particular ideology such as communism or Darwinism. In this case communism or Darwinism was a substitute of religion for some people.

What does it mean or imply that there are substitutes of religion in the world? Doubtlessly it indicates that religiosity in the human nature remains even if the traditional religions are abandoned. This religiosity is revealed in one way or another.

There are numerous scholars who wrote and published books on

the religious experience. Famous among them is William James (1842-1910) who is the author of *The Varieties of Religious Experience*. This book introduces uncommon and remarkable experiences and the reader is surprised by the great variety of religious experience. This writer regrets that he cannot introduce these remarkable religious experiences presented in this book. Instead I would like to tell my own religious experience which is uncommon and remarkable. It is a miraculous instantaneous healing of my 12 year-old eyes disease which the eye-specialists could not cure despite their best efforts and expertise.

This miraculous healing of my eyes-disease happened on Thursday, November 15, 1962 at about 10:30a.m., and it happened in a bed room of our house. I had a premonition and I have been expecting for several days that some supernatural event would take place and my 12 year-old eyes disease would be healed. I believed in God and believed also that most of the miracle stories in the Bible are not fictions but real stories. I have accepted the Christian creed that the Bible was written by those who had been inspired by the Holy Spirit of God, such as the prophets and the apostles. I had a great interest in the stories in the gospels of the New Testament that Jesus healed all the sick people who came to Him, especially in the story that Jesus opened the eyes of the blind. It is because I had an eyes-disease myself and the doctors could not cure it and it was getting worse. I feared that I might lose my eye-sight and become a blind man. I was desperate with no one to turn to for help. In this desperate situation what can I do except to turn to God for help.

The stories of the miraculous healings in the Bible, gave me a hope. I had a belief and a hope that as God really exists He would be able to heal my diseased eyes. But my belief was not strong. Belief and doubt coexisted in my mind. I realized that as long as belief and doubt coexisted in my mind the miracle of healing would not happen. I have to firmly believe in God's power and promise if I am to receive the Divine blessing of healing. This is a teaching of the Bible regarding the supernatural healing of diseases. Jesus said: "If you believe, you will see the glory of God". (John 11:40)

Here let me describe the symptom of my eyes-disease. At the initial stage of the disease 12 years earlier it bothered me very little and I could lead a normal life. But my problem got worse as time passed. My problem had started 12 years earlier when my body

weakened and my health deteriorated. One day I even fainted, but I recovered my consciousness quickly and I never fainted again. However, keeping my eyes open gave me a discomfort and keeping the eyes closed was comfortable. Soon keeping the eyes open gave me not merely a discomfort, but also some pain. Winds, especially warm winds caused pain in my eyes.

After washing my face I could not open my eyes for pain for a few hours. If I force my eyes to keep open, I felt the eye-balls to be warmed and swollen. Such being the case I did not wash my face in the morning, and washed the face before going to bed. If I force my eyes to keep open to read news-papers or books, I felt my eye-balls swell and I had a head-ache. So I did not read news-papers and instead listened to the radio. After the television was invented and popularized, watching TV did not give me a joy because watching TV caused pain in my eyes. I did not go to the movie house because I could not watch movies. It was impossible for me to have a normal ordinary job. Fortunately I found a job which required only two hours of work a day. Even this job was a burden for me.

A Presbyterian minister arranged a marriage for me to his sister-in-law. So we got married in April, 1962. I did not tell her the details of my eyes-problem. I felt guilty for that. But I justified my marriage to her because I had a belief that God will heal my eyes-disease before long. I believed in God and trusted. After the marriage my wife learned the details of my eyes-disease. But she did not blame me and we were happy in our married life.

Every day she read for me books about the divine healing and the testimonies of those who had received the miraculous healing. My whole mind and soul were focused on receiving the miraculous healing of my eyes. And day and night I called on God for it. At no time in my life I have prayed so fervently as this time. My mind and soul were heated up and my trust in God was strengthened. In Jeremiah 29: 12-13, we read these words of God:

> Then you will call upon me and
> come and pray to me, and I will listen to you.
> You will seek me and find me
> when you seek me with all your heart.
> I will be found by you.

A week passed after my mind and soul began to be heated up. And I felt the Divine Presence near me. I anticipated that some supernatural event will occur to me very soon. The anticipated supernatural event happened on Thursday, November 15, 1962 at about 10: 30 in the morning. I was sitting on the floor of our bed room. And my mind and soul were concentrated on the Divine Presence near me. There was nothing between the Presence of God and myself and there was nothing in my mind except the awareness of God's Presence. And a small patch of darkness which remained at one corner of my mind, namely, a little doubt was cleared up. My mind was 100 percent lighted up by a brilliant light. I expected that a great event that I had been expecting will happen at this moment. At that very moment the Divine Power that had been above the roof of our house started to come down slowly. I felt that the Divine Power or the Divine Presence touched the red tile roof of the house and continued to come down slowly and touched my head and two eyes. I felt hot in my eyes. Something like a weak electric current ran through my whole body from the top of my head to the toes of the feet. And I realized that my diseased eyes were being healed by the Divine Power at that moment. If there were other diseases in my body, I believe that they were all healed. At the very moment the Divine Power touched my eyes, I felt relief in my eyes, and everything in the surroundings looked brighter. The Divine Power which I felt like a weak electric current touched my body and wrought a miracle. And the Power left me quickly. The Power stayed in my body for 4 or 5 seconds perhaps. I repeat: my eyes were healed completely at the very moment the Divine Power touched the eyes. It was an instant healing.

In retrospect, it seems that this astonishing miracle which occurred to me many years ago is like a happening in a dream and not a real event. But it was not a happening in a dream. It happened on Thursday, November 15, 1962 at about 10:30 a.m. namely, 50 years ago.

After 50 years my eyes are well and I am leading a normal life. In the meantime I have written and published 4 books including this one. In preparation for writing my own books, I have read many books written by others.

What is surprising to me is that in addition to the miraculous

instantaneous healing of my diseased eyes, I was aware of the movement of the Divine Power that healed my eyes. That is to say, I knew that the Divine Power that had been above the red tile roof of our house came down slowly, penetrated the roof as if it were nothing, continued to come down and touched my head and eyes, and reached the toes of my two feet. I also knew that the Power stayed in my body for 4 or 5 seconds and left. I wonder, how did I know that movement of the Divine Power? It was not by my body organs, namely, eyes, ears, skin or touching with hands. Therefore, it appears that we, humans, have an ability to be aware of some supernatural phenomena.

After the instantaneous healing of my eyes, I could read books for decades and I led a normal life. The eyes disease did not come back to me. It was a complete healing. Following the healing of the eyes, I started to do things that I had been unable to do. For instance, I went to a movie house to watch movies. I went to the movie house to ascertain on that day the incredible sudden healing of my two eyes, and not to enjoy movies.

On that day, I drove my car to the downtown area where a few movie houses and theaters are located. And I walked into a movie house and watched a movie which lasted for about two hours. When the movie ended I came outside. My two eyes were very comfortable. So I walked into another movie house which was nearby. When the movie ended, my eyes were comfortable. So I walked into the third movie house which was nearby. When I came outside after the third movie, I felt some fatigue in my eyes. But it was natural because I watched movies and news for over 6 hours. Thus I ascertained that the instantaneous miraculous healing of my eyes is true and a fact. After the healing, I began to read books, many books. After consulting with my wife I decided to study theology and become a theologian and a minister. I received a doctorate in theology in 1973 from Emmanuel College in the University of Toronto, Canada. And I was ordained as a minister of the United Church of Canada. Here I bring to an end my story of my personal religious experience, namely, the miraculous supernatural healing of my diseased eyes.

Here is a question to consider, how is such an instantaneous healing of a disease to be interpreted? Is it to be recognized as a supernatural miracle? Or is it to be interpreted otherwise? The

"naturalists" do not believe in God and do not recognize a miracle and say that there is no such thing as a miracle. Therefore they interpret the instantaneous healing of my diseased eyes from the naturalistic point of view. For instance, some naturalists present a psychological explanation. They say that such a healing did happen because I was very anxious to have a healing and had a belief that it could be healed; and that man's mental power can bring about a physical change.

But I do not take this psychological explanation seriously. A merely psychological explanation is inadequate in this case because the 12 year-old eyes disease which several eyes specialists could not cure despite their best efforts and expertise was getting worse and I feared my blindness. Does an instantaneous miraculous healing of a serious disease of the human body happen frequently? As for me, I have not seen or heard about such a healing. Have you? Even if the psychological explanation were acceptable, it is favorable to Theism and not to Atheism or materialism, because it indicates that the nature and the metaphysical principle of the real world are spiritual rather than material.

Also, even if my eyes disease were healed through the laws of nature, we can interpret that God healed it by using the laws of nature. According to Theism both nature and the laws of nature were created by God. Therefore there is nothing strange that God used the laws of nature for healing.

As I mentioned already, the religious experience has a great variety in kind. In the following I would like to introduce a very different kind of religious experience which a person by the name of Ernest Nielson had. I met Nielson and his wife in 1982 in Sicamus, the Province of British Columbia. Nielson was a member of the Sicamus United Church that I ministered to as its minister. Sicamus is a small town with the population of around one thousand inhabitants. And the Province of B.C. is located in the Western part of Canada. In the town of Sicamus Ernest Nielson was a well-known person because of his extraordinary life style. Every day he devoted himself to the service for others. He served the community and the church in whatever the way he could. To serve others who needed his service and help was the purpose of his life and his philosophy of life, so to speak. So Ernest Nielson was not only well-known in the town, but

also he amazed people. People in the town wondered how a person can dedicate himself to serving others everyday like Nielson.

One day I met with Nielson in the manse of the church. We had a close relationship. He was about 68 or 69 years old at that time. I asked him how he had come to choose such a life style. He answered with a small voice that he had died when he was young and had gone to heaven. But he was told that he should return to the earth. He liked heaven and wished to stay there. Yet he was told again to return to the earth. So he came back. He did not say more than this. I was curious about heaven and wanted to hear more about heaven. But he was reticent and reserved. Therefore I restrained myself and did not ask him about heaven. I controlled my curiosity.

Ernest Nielson is not the only one who had been to heaven and came back. There are other individuals who had similar experiences. One of them is Harvey Krots who was a used-car dealer at Listwol, the Province of Ontario, Canada.

Another individual who had a similar experience is William Tennant, a Presbyterian minister who founded a small college in Pennsylvania, U.S.A. When he was 26 years of age he fainted and died, but after three days he revived. During the three days he (his soul) had been in heaven. He says: "I saw an innumerable host of happy beings surrounding the inexpressible glory, in acts of adoration and joyous worship....I heard their songs and hallelujahs of thanksgiving and praise, with unspeakable rapture. I then applied to my conductor and requested permission to join the happy throng; on which he said, 'You must return to the earth'. The three days during which I had appeared lifeless seemed to me not more than 20 minutes. The idea of returning to this world of sorrow and trouble gave me such a shock, that I fainted repeatedly".

This account of William Tennant appeared in a theological journal *Theology Today* in July, 1977.

The apostle Paul also tells that he has been to "the third heaven" and has come back. (2 Corinthians 12: 1-4) The apostle also tells that he is looking forward to going to heaven and "to be at home with the Lord". (ibid. 5: 1-8)

PART THREE

Man's Knowledge of God through
God's Special Revelation

CHAPTER 10

Man's Knowledge of God through God's Special Revelation

In this book our primary concerns is the Existence of God. Inseparably connected with this our primary concern is: What kind of God is He? Namely, God's nature and character. To speak specifically, is He a "personal" God or an impersonal Being? There are more specific questions.

However, there is no way for us the human beings to know the answer without God's self-revelation. In other words, He is a Transcendent Deity. According to the creed of Christianity, God made special self-revelations and the contents are testified in the Holy Scripture. Therefore, let us study the Scripture. God's special self-revelations are mostly testified in the Old Testament. In the Old Testament God introduced Himself as "Yahweh" the Lord. The exact meaning of Yahweh is uncertain. In Exodus 34: 6, God proclaimed His Name,

> Yahweh, Yahweh, the compassionate and gracious God, slow to anger, abounding in love and faithfulness, maintaining love to a thousand generations, and forgiving wickedness, rebellion and sin. Yet He does not leave the guilty unpunished.

So God is a "personal" Deity.

The God Yahweh demands total allegiance from His people and says,

> You shall have no other gods before me,
> You shall not make for yourself a graven image
> for I Yahweh your God am a jealous God. (Exodus 10: 3f)

And God claims,

> I am Yahweh. There is no God apart from me.
> I am a righteous God and a Saviour;
> There is none but me.
> Turn to me and be saved
> All you ends of the earth.
> For I am God, and there is no other. (Isaiah 45: 18, 21-22)

> My salvation will last forever,
> My righteousness will never fail. (Isaiah 51:6)

So God is a Deity of moral character, and He saves "all you ends of the earth". In other words, God saves even those who live at the ends of the earth.

In the book of Genesis in the Old Testament we read the story of Abraham. God enters into a relationship with Abraham who is an individual human being. God calls Abraham "My friend" (Isaiah 41: 8). Obviously God is a personal Deity. Personality is the main characteristic that God and the human being share. In Genesis we read that God created man in the image and after the likeness of God (1:26). I repeat, personality is the main characteristic that God and the human being share.

Morality is another characteristic that God and the human being share. Only personal beings can have morality. And only a personal Deity can esteem morality. God's personality and morality are inseparably tied. Since man was created in the image and after the likeness of God, man's personality and morality also are inseparably tied. Man (even an atheist) knows the difference between good and evil and between right and wrong; man also knows that he should

choose and practice good and right. Morality is part of the human nature.

God proclaimed that He is a righteous God and a Savior. (Isaiah 45: 21) Thus He put emphasis on His moral character. Human beings can make history because they are free personal beings. God also who is a personal and moral Deity can make history and can take part in the history of the world. Since both God and the human beings take parts in the world history, the history has a greater significance. And it becomes God's redemptive history which is testified in the Holy Scriptures. According to the New Testament, Christ who is the Son of God took a human body and came to the world to save mankind.

Only personal beings can have a relationship with other personal beings and can love others and can be gracious. And only personal beings appreciate it and can be grateful. And the human beings who are sinners are very thankful to God for His amazing saving grace for them which they do not deserve.

Yahweh's Covenant Love and Faithfulness to His Promises

God said that He is "abounding in love and faithfulness". (Exodus 34: 6) The phrase 'steadfast love and faithfulness' becomes a standard formula in reference to God's reliability in living up to His promise. (Genesis 32: 10; Psalm 57: 3, 10) Here I summarize the foregoing. In the Old Testament as a whole God is a Person with the name Yahweh. He acts in history; He reveals Himself to human persons; and He enters into covenant relations with them. And He is faithful to the terms of the covenant, namely, to His promises.

Yahweh's relationship to the people of Israel who are the descendants of Abraham whom God called "my friend", was as close and emotional as that of a human father to his only child. God said in reference to the historical event of the Exodus out of Egypt in the past:

> When Israel was a child, I loved him, and out of
> Egypt I called my son. (Hosea 11: 1)

No human kinship is closer, and no emotion stronger, than that between parent and child, yet the Lord's kinship to His people is

even closer, and His covenant love even stronger than anything else humans can experience or even imagine! The Lord said:

> Can a woman forget her sucking child, that she
> should have no compassion on the son of her womb?
> Even these may forget, yet I will not forget you.
> (Isaiah 49: 15)

Yahweh's Caring Love to the Poor and the Oppressed

God identifies with the suffering and oppressed whoever they may be. During their sojourn in Egypt, the Israelites were the persecuted minority (Exodus 1: 7-14). They groaned under their bondage, and cried out for help, and their cry under bondage came to God. God heard their groaning, and God remembered His covenant with Abraham. Subsequently God called Moses and said,

> I have seen the affliction of my people
> who are in Egypt, and have heard their cry
> because of their taskmasters;
> I know their sufferings, and I have come down to deliver them
> out of the hand of the Egyptians. (Exodus 3: 7f)

Israel here is the type of those people, throughput history, who have been subjugated and exploited by those with more power. (Genesis 31: 41f; Isaiah 41: 14-20) And God Himself becomes the defender of those who have no one to defend them. (Deuteronomy 5: 15, 10: 15-20)

> God executes justice for the fatherless
> and the widow and loves the sojourner,
> giving him food and clothing. (Deuteronomy 10: 18)

Yahweh the God is described as "Father of the fatherless and protector of the widows". (Psalm 68: 5) He is the God who "delivers the needy, the poor who has no helper" (Psalm 72: 12), and "who executes justice for the oppressed; and who gives food to the hungry". (Psalm 146: 7)

When God's chosen people (Israel) disregarded His commandments

and exploited the poor, or neglected the needy, there was no uncertainty as to where Yahweh's affinity of kinship was directed:

I know how many are your offences and how great your sins…….
I hate, I despise your religious feasts; I
cannot stand your assemblies.
Even though you bring me burnt
offerings and grain offerings,
I will not accept them….
Away with the noise of your songs!
I will not listen to the music of your harps.
But let justice roll on like a river,
righteousness like a never-failing stream! (Amos 5: 21-29)

CHAPTER 11

The Reality of Heaven and Hell

According to the testimony of the New Testament, Jesus Christ who is the Son of God came to this world with a human body (John 1: 14) and was crucified on the cross to atone the sins of human beings. The atoning death of Christ was prophesied in the Old Testament, (e.g. Isaiah 53 and Psalm 22) and He is called "the Suffering Servant of the Lord".

Christianity teaches the existence of a personal God and the personal relation between God and man. Christianity is unique in its doctrine of reconciliation through the atonement of man's sin. The heart of reconciliation lies in the restoration of a true personal relation between God and man (which has lapsed into man's own act of alienation against God), in other words, in the forgiveness of sins.

An important question to raise here is, Why is the atonement of the sins of mankind necessary by the death of Jesus the Son of God? The answer is, Without the atonement of sins by the death of the Son of God, the humans will be punished for their sins and will go to hell according to the laws of God. The atonement of sins means the forgiveness of sins. If their sins are forgiven, the sinners will be saved; which means that they will go to heaven after their lives on the earth.

Jesus said,

> God so loved the world that He gave His only Son
> that whoever believes in him should not perish
> but have eternal life. (John 3: 16)

What is the meaning of the expression "God gave His only Son"? It means that God has let His Son Jesus die for the sins of the world, namely, His death on the cross. In theology, it is called substitution or vicarious punishment. Only because Jesus died on the cross on behalf of sinners, the sinful human beings are exempt from the punishment in the hell. Do you believe the existence of heaven and hell? The teaching of the New Testament endorses the belief. Jesus mentioned about the hell more often than about the heaven. (e.g. Matthew 18: 9, 23: 33, 25: 46, 13: 41-42, 50, 5: 27-30) Nothing should be allowed to detract from the seriousness of Jesus' warnings about the terrible reality of God's judgment in the world to come.

Jesus gave this terrifying warning to the scribes and Pharisees who were corrupt religious leaders of His days.

> You serpents, you brood of vipers,
> how are you to escape being sentenced
> to hell? (Matthew 23: 33)

Jesus who was gracious and compassionate to the needy and the helpless (e.g. Matthew 25: 31-46) was stern to the corrupt religious leaders. I quoted above John 3: 16. I quote this important passage again.

> God so loved the world that He gave His only Son,
> that whoever believes in him
> should not perish but have eternal life.

Please, read this passage carefully. This passage implies the reality of heaven and hell.

I am aware that there are some people who ridicule the idea of heaven and hell. But there are individuals who had been to heaven or to hell and have come back to tell their experiences. Some individuals revive after they have been dead; in other words their hearts beat again and they breathe again and recover their consciousness.

Thanks to the progress of resuscitation medicine, nowadays more individuals revive after their heart beat and breathing stopped and their consciousness was lost. And some of them tell their experiences while they were dead. They say that they (their souls) have been to heaven or to hell. Those who have been to heaven tell their happy experiences there whereas those who have been to hell tell terrifying stories.

I have a book titled *To hell and Back* written by Maurice S. Rawlings, M. D. The book was published in 1993 by Thomas Nelson Publisher, Nashville. The book of 255 pages provides startling new evidence of life after death. The author of the book who is a well-known heart specialist tells his treatment of the patients with heart disease and also introduces what he heard from the patients who have been dead and have been to heaven or to hell.

In Chapter 9 The Religious Experience in this book written by me, there is a story about a dedicated Christian by the name of Ernest Nielson. Nielson died and he (his soul) went to heaven; but he was told to go back to the earth although he liked heaven and wanted to stay there. His soul came back and his body revived and he lived a devout Christian life for several years. He lived in a town named Sicamus, which is located in the mountainous area in the Western Canada. Nielson was one of my close friends. Nielson is survived by his wife Marion who is a good Christian.

This world in which we live is not a Paradise. There are suffering, pain, unhappiness and disillusionment in this world. Part of the reason is the sins of the human beings. And part of the reason is God's Providence. Because of suffering, pain and disillusionment in this world, we, humans have a longing to go to heaven and are looking forward to the day we shall get there. The existence of heaven is a corollary of the Existence of God. A corollary is a proposition which can be inferred from one already proved as self-evidently true.

EPILOGUE

Here we need to consider an important question. The question is: Why is it that some individuals refuse to believe in God despite the fact that there are numerous clues (and even evidences) pointing to the existence of God? My initial short answer is: A person's belief in God and other religious beliefs are not merely an intellectual matter which is dealt with by reason (intellect). The person's will and emotion and the circumstantial factors are involved. "A person's reason can bend any direction". (Pascal)

An evil man does not believe the existence of God. And he hopes that there is no God and there is no more world after this world. He has a fear that if there is a God and there is another world after this world, he will be punished (he fears that he may go to hell). And he believes what he hopes. An evil man does not want to meet God somewhat like a criminal does not want to meet the police. He hopes that there is no God and he believes what he hopes. Thus, there is a hidden motive behind a person's disbelief in God. Often disbelief in God is a matter of will. I repeat that a person's reason (intellect) can bend any direction. I illustrate my point. There was a famous atheistic philosopher by the name of Bertrand Russell (1872-1970). He married 4 times and led an immoral life. Obviously Russell's atheism is related with his immoral life, and vice versa.

There was the so-called Flat Earth Social in Britain until the middle of the 20th century. The members of the Society insisted that the earth on which we live is flat-shaped like the surface of a table and not shaped like a ball. The assertion of atheists that God does not exist, despite the fact that there are abundant clues (and even

evidences) pointing to the existence of a Mind behind the Universe, resembles the stubborn insistence of the Flat Earth Society.

In the debate between the theists and the atheists on the question of the existence of God, the will and the emotion are usually involved. It is not exclusively a debate by reason (intellect). Let me illustrate my point. Two men were walking together on a road in the rural area. Then they saw a man who was going in the direction of a river with a fishing rod and an empty basket. One of the two men said, "I think he is going to the river for fishing". But the other man said, "No, I don't think so. He is just walking in the direction of the river with a fishing rod and a basket. That's all". The two men continued their heated argument for several hours without a compromise. Unfortunately the debate between the theists and the atheists on the question of the existence of God resembles the argument of these two men in some respects.

A Christian hymn says, "I see God everywhere and I sense mystery everywhere". However, an atheist said, "I see God nowhere. I sense mystery nowhere. The universe seems pointless". This remark was made by an atheistic physicist by the name of Steven Weinberg in his book *The First Three Minutes* (1977). Weinberg quoted the astronomer Margaret Geller's saying with approval, "Why should the universe have a point? What point? It's just a physical system. What point is there?" Quoted in his another book *Dreams of A Final Theory* (1992) P.255, Weinberg says that religion is "a wishful thinking". Unfortunately these atheistic scientists who are clever in the matters related with natural science are spiritually blind. Needless to say, it is not just atheistic scientists alone that are spiritually blind. We see spiritually blind people practically everywhere in this world. In my humble view these spiritually blind men and women are the most unfortunate people. They are even more unfortunate than those really blind people who cannot see and walk slowly with a cane.

Weinberg says that religion is a wishful thinking. This remark indicates that Weinberg does not understand what religion is. Religion is about maintaining a right relationship with the God who has brought the universe and the human beings into existence and who holds our destiny in His hands. According to the Bible God is a moral and personal Deity and we, humans, can have a personal

relationship with God because God created every human being in the image and after the likeness of God. (Genesis 1: 26-27)

God called Abraham who is the prominent forefather of the Israelites "My friend" (Isaiah 41: 8). And God "spoke to Moses (a prophet) as a man speaks to his friend". (Exodus 33: 11) The Bible also says that God is "merciful and gracious, slow to anger, and abounding in steadfast love and faithfulness" (Exodus 34: 6). And the Bible urges us, "You shall love the Lord your God with all your heart, and with all your soul, and with all your might". (Deuteronomy 6:4) We love God because He loved us first and forgives our sins if we repent. In the New Testament Jesus said, "God so loved the world that He gave His only Son, that whoever believes in him should not perish but have eternal life". (John 3:16) So, God is a personal Deity of moral character, with whom we can have a personal relationship. And God hears our prayer. Jesus taught us to say: "Our Father Who art in heaven". (The Lord's Prayer)

NOTES

Introduction
1. Paul Davies, *The Mind of God* (New York: Simon & Schuster, 1992) p.52
2. David Bohm, *Science, Order and Creativity* (New York: Bantam, 1987) p.102
3. Paul Davies, *God and the New Physics* (New York: Simon & Schuster, 1983) p.216
4. Paul Davies, *The Mind of God*, p.p. 68, 73, 88, 89
5. Max Planck, *Where is Science Going?*, Translated by James Murphy (New York: Norton, 1977) p.168
6. Werner Heisenberg, *Across the Frontiers*, translated by Peter Heath (San Francisco: Harper and Raw, 1974) p.213

Chapter 2
1. Xenophon: MEMORABLIA, I, iv, 2-7
2. Issac Newton, *Philosophiac Naturalis Principia Mathematica* (1687) Book III, General Scholium
3. Robert Boyle, *"A Disquisition About the Final Causes"* in Works
4. Rubel Shelly, *Prepare to Answer* (1990) quoted in p.57
5. Paul Davies, *The Mind of God* (1992) p. 203

Chapter 3
1. Eugene Wigner, *The Unreasonable Effectiveness of Mathematics in the Natural Science* (1960) p.p. 233, 237
2. Quoted by John Barrow in *The World within the World* (New York: Oxford University Press, 1990) p.349
3. John Polkingkorne, *The Way the World is* (London: Triangle, 1983), pp. 9-10

4. William G. Pollard, *Man on a Spaceship* (Claremont, California: Publication by Claremont Graduate School and University Centre for the Claremont College) pp. 50-51
5. John Polkinghorne, *Science and Creation* (London: SPCK, 1988) p. 22
6. Exploring Chaos, *A Guide to the New Science of Discovery,* edited by Nina Hall, p. 221
7. Paul Davies and John Gribbin, *THE MATTER MYTH,* (Published by Simon & Schuster, New York, 1992) p.9

Chapter 4
1. Paul Davies, *God and the New Physics,* New York: Simon and Schuster, Inc. (1983) p.179
2. Sir Denys Wilkinson, *Our Universes* (New York: Columbia University Press. 1991) p.169
3. Ibid. p.195

Chapter 5
1. David Hume, *Dialogues Concerning Natural Religion* (Indianapolis: Bobbs-Merrill Educational Publishing, 1947), p. 131
2. Ibid. pp.134-135
3. Ibid. p.37
4. Ibid. p.226-7
5. Ibid. p.227
6. Ibid. p.142
7. Ibid. p.227
8. Immanuel Kant, *CRITIQUE OF PURE REASON,* translated by Norman Kemp Smith from German, St. Martin's Press, New York (1929) p.530
9. Ibid. p.531
10. Ibid. p. 521
11. Ibid. p. 520
12. Ibid. p.519
13. Ibid. p.520
14. Ibid. p.522
15. Karl Jaspers, *Perennial Scope.* pp.34-5
16. Paul Davies, *Superforce,* published by Simon & Schuster Inc. 1984. p.242
17. Ibid. p.233
18. Ibid. pp.235-6

19. Keith Ward, *HOLDING FAST TO GOD*, (London; SPCK, 1982) P.22
20. Ibid. p.166
21. I. Kant, *CRITIQUE OF JEDGMENT*, Hafner press, New York, 1951, translator's introduction

Chapter 6

1. Karl Popper, *Objective Knowledge*, (Toronto: Oxford University Press, 1972) Preface
2. William Temple, *NATURE, MAN AND GOD*, (London: Macmillan & Co Ltd) 1964. P.129
3. Lawrence Henderson, *The FITNESS OF THE ENVIRONMENT*, published by The Macmillan Company, 1913. pp.5,7
4. Lawrence Henderson, *The Order of Nature*, published by Books For Libraries Press, Freeport New York, 1917. pp.3,4,5,6
5. Sir Denys Wilkinson, *OUR UNIVERSEs*, published by Columbia University Press, New York. 1991. pp.190-191
6. Ibid. pp.195-196

Chapter 7

1. Immanuel Kant: *Critique of Judgment* (Hafner Press, A Division of Macmillan Publishing Co., Inc. New York, 1951) pp.85, 96
2. Steven Weinberg, *Dreams of a Final Theory*, A division of Random House, Inc., (New York) 1992, p.153
3. S. Radhakrishna, *Eastern Religions and Western Thought* (1939), Oxford University Press, p.126
4. Lincoln Barnett, *The Universe and Dr. Einstein* (New York: Signet, 1948) p.118

Chapter 8

1. Paul Tillich, *MORALITY AND BEYOND*, Published by Harper & Row, Publisher, New York 1963, pp.26-27

Chapter 9

1. John Macquarrie, *In Search of Humanity* – A Theological and Philosophical Approach – Published by The Crossroad Publishing Company, New York, N.Y. (1982) p.213